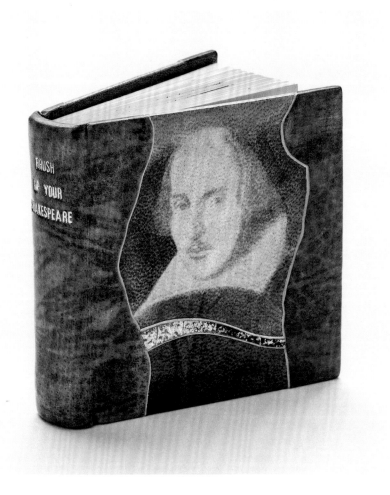

But the poet of them all
Who will start 'em simply ravin'
Is the poet people call
The Bard of Stratford on Avon

—from "Brush Up Your Shakespeare"
in *Kiss Me, Kate* (1948) by Cole Porter

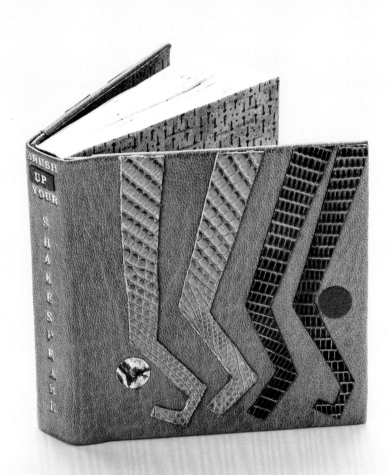

THE POET OF THEM ALL

William Shakespeare and Miniature Designer Bindings
from the Collection of Neale and Margaret Albert

Elisabeth R. Fairman

with an essay by
James Reid-Cunningham

Yale Center for British Art, New Haven

DISTRIBUTED BY

Yale University Press, New Haven and London

This publication accompanies the exhibitions:

"The Poet of Them All": William Shakespeare and Miniature Designer Bindings from the Collection of Neale and Margaret Albert, organized by the Yale Center for British Art, New Haven, and on view June 16–August 21, 2016. Exhibition curated by Elisabeth R. Fairman.

"Brush Up Your Shakespeare": Miniature Designer Bindings from the Collection of Neale and Margaret Albert, hosted by the Grolier Club, New York, and on view March 24– May 28, 2016. Exhibition curated by Neale Albert and designed by Russ Drisch.

This publication has been generously supported by The Wendy's Company.

Published by the Yale Center for British Art
britishart.yale.edu

Distributed by Yale University Press, New Haven and London
yalebooks.com/art

LIBRARY OF CONGRESS CATALOGING-IN-PUBLICATION DATA

The poet of them all : William Shakespeare and miniature designer bindings from the collection of Neale and Margaret Albert / Elisabeth R. Fairman ; with an essay by James Reid-Cunningham.
pages cm
"This publication accompanies the exhibition 'The Poet of Them All' : William Shakespeare and Miniature Designer Bindings from the Collection of Neale and Margaret Albert, organized by the Yale Center for British Art, New Haven, and on view June 16–August 21, 2016."
Includes index.
ISBN 978-0-300-21912-8 (hardcover)
I. Fine bindings—Exhibitions. 2. Miniature books—Bibliography—Exhibitions. 3. Shakespeare, William, 1564–1616—Bibliography—Exhibitions. 4. Albert, Neale M.—Library—Exhibitions. I. Fairman, Elisabeth R. II. Reid-Cunningham, James. Enigmatic devices. III. Yale Center for British Art, organizer, host institution.
Z269.3.F55 P64 2016
2015033572
A catalogue record for this book is available from the British Library.

Designed by Miko McGinty, in collaboration with Claire Bidwell and Rita Jules
Color separations by Professional Graphics, Rockford, Illinois
Printed and bound in Italy by Conti Tipocolor SpA, Florence

Front cover: *Brush Up Your Shakespeare* (New York: Piccolo Press, 2009), bound by Robert Wu, 2015.

Endpapers: Hannah Brown, hand-drawn and digitally printed design, 2015, derived from the original illustrations by Seymour Chwast in *Brush Up Your Shakespeare* (New York: Piccolo Press, 2009).

Back cover: *Brush Up Your Shakespeare* (New York: Piccolo Press, 2009), bound by Michael Wilcox, 2010.

Half-title page: *Brush Up Your Shakespeare* (New York: Piccolo Press, 2009), bound by Julian Thomas, 2011.

Frontispiece: *Brush Up Your Shakespeare* (New York: Piccolo Press, 2009), bound by Monique Lallier, 2010.

Page 6: *Brush Up Your Shakespeare* (New York: Piccolo Press, 2009), bound by Yehuda Miklaf, 2010.

Colophon: Gabrielle Fox, "Globe Theatre" from *Queen Mab* (Cincinnati: Squiggle Press, 2007), wood engraving.

For Margaret

… why, man, she is mine own,
And I as rich in having such a jewel
As twenty seas, if all their sand were pearl,
The water nectar and the rocks pure gold.

—William Shakespeare, *The Two Gentlemen of Verona*
(II, iv, lines 828-31)

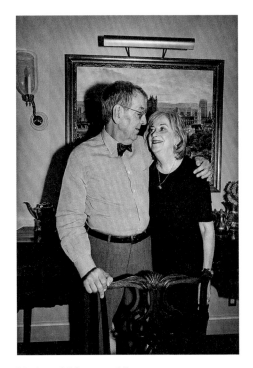

Neale and Margaret Albert, 2013.
Photograph by Lee Friedlander

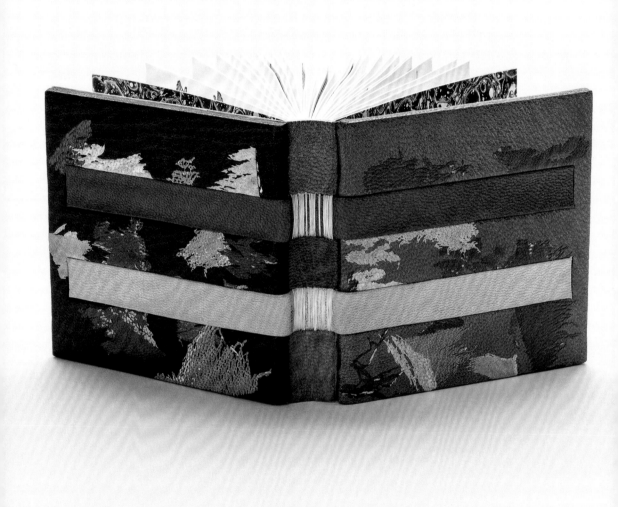

CONTENTS

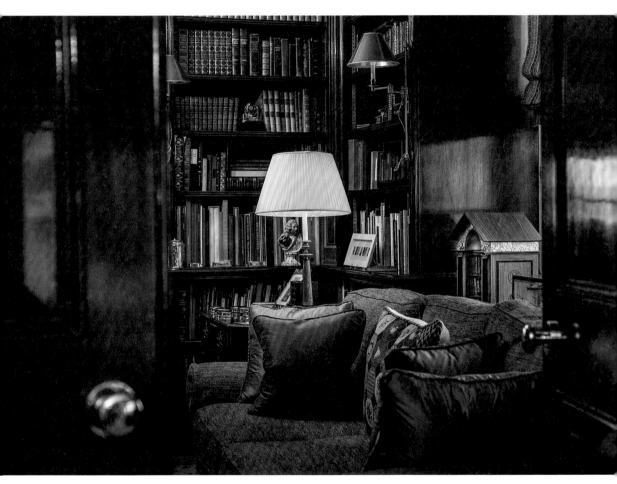

A glimpse of the study in the Alberts' New York apartment. The roofed bookcase on the windowsill, designed by London bespoke-furniture maker Tim Gosling, houses a set of Shakespeare's works.

Director's Foreword

The book arts transcend traditional categories of making and knowing. They include objects that are created to be handled and looked at as much as they are meant to be read, complicating conventional notions of collaboration between different kinds of artists. This vital field of artistic production is characterized by its powerful links to the practices of painters, sculptors, and draftsmen, as well as writers, printers, papermakers, and publishers. Miniature books can provide a particular challenge to taxonomic boundaries because they defy expectations about human scales of perception. Producing such works requires the same artistic resources that all practitioners of their respective arts on a typical scale must master. But these objects also prompt reconsiderations of relationships between creators and artistic products, and between viewers and objects, by appearing in a form that is both intimately familiar and conspicuously unconventional. In the present exhibition, *"The Poet of Them All": William Shakespeare and Miniature Designer Bindings from the Collection of Neale and Margaret Albert*, a painstakingly assembled collection of miniature books illuminates the wide array of artistic responses that Shakespeare's plays and poems have continued to inspire in the four hundred years since he wrote them, and provides an overview of a vibrant branch of twenty-first-century practice in the book arts.

This exhibition, along with its associated publication, continues a series of projects undertaken at the Yale Center for British Art wherein we consider the art of the book. This field of endeavor has been explored through exhibitions and publications such as *"The Beauty of Life": William Morris and the Art of Design*, produced in collaboration with the Huntington Library, Art Collections, and Botanical Gardens; and *Structured Elegance: Bookbindings and Jewelry by Romilly Saumarez Smith*. Elisabeth Fairman, Chief Curator of Rare Books and Manuscripts at the Center, served as an organizing curator for both of these earlier projects. She has here applied her keen sensitivity to the power of books as art objects, along with a body of knowledge cultivated over decades of investigating books worthy of close attention, in presenting

a collection that is at once a deeply personal project and a potent demonstration of the continued vitality of the book arts at the present moment.

Neale and Margaret Albert must be credited with a singular commitment to maintaining that vitality, as shown by their collection, and by the exhibition that has been realized through their generous collaboration with Elisabeth and the Center. While the exhibition presents exquisite interventions into the published legacy of Great Britain's most revered literary figure, it also illuminates the world of designer bookbinding, an area of the book arts too often overlooked and perhaps requiring the greatest perseverance to pursue in miniature.

The Alberts' generosity to the Center is of a piece with their generosity to Yale University more broadly. Neale's attachment to the university arises in large part from his experience at the Yale Law School, from which he graduated with honors in 1961. Since that time, he has served as a member of its Founders Society and been elected to the Executive Committee of the Alumni Association of the Yale Law School. Over the past several decades he has combined his passion for photography with his training in the law by pursuing the art himself, by representing many of its outstanding practitioners—including Lee Friedlander, Helen Levitt, Sally Mann, Mario Testino, and Robert Frank—and by donating photographs to the Yale University Art Gallery. Thus far, he has added over four hundred photographs to their collections and intends to donate dozens more, as well as over 150 additional works in other media ranging from prints and watercolors to paintings. Indeed, his commitment as a supporter of Yale's arts institutions is as remarkable as his energy in serving its Law School. We look forward to providing a permanent home at the Center for a similarly arresting array of objects. In addition to the collection presented here, and further holdings of miniature room displays with furnishings and accessories, Neale has gathered collections of antique English brass objects, full-size designer bindings (several of which also relate to Shakespeare and are included in this exhibition), and fine press books that will complement the remarkable group of miniature objects that sets his collecting practice apart. Starting with *"The Poet of Them All,"* we at the Center are honored and privileged to steward those facets of the collection that will come to the Center over time and to work with the Alberts to make these accessible to the wider public in the most innovative and exciting of ways.

Neale's collecting practice is also distinguished by his investment in commissioning works from artists, a pursuit made all the more extraordinary by the combination of humility, affection, and artistic freedom that character-

izes his commissions. Elisabeth has been able to document much of this in her extensive correspondence with the artists whom Albert has commissioned. She not only has contacted all of those who could be located but also has mined Neale's archive for insights into the innovative materials and techniques deployed by these artists (too many to list here, although their voices can be heard in the pages that follow) as they strive to fulfill Neale's faith in their abilities and judgment while exercising the nearly complete artistic freedom he affords them. The compassion embedded in that charge has won him friends whose work he treasures, but whom, in most instances, he has never met. We are touched by all of their contributions, especially that of George Kirkpatrick, who was inspired to return to designer bookbinding after an illness he considered career-ending when he realized how Neale would receive his efforts. George eloquently described his friend's offer of a commission in a note to Elisabeth written on March 14, 2015: "He said 'You do what you want and I will love it'. . . . Who could resist doing anything other than your best when you hear that? I think the 'I will love it' is the secret." Some of the artists have also demonstrated their appreciation by enhancing the Center's exhibition and publication by lending personal objects from their studios: for this, we would like to thank Gabrielle Fox, who has graciously illuminated her craft through the loan of specialized tools for miniature bookbinding; and Philip Smith, whose family also assisted with the preservation and transportation of notebooks that provide a stunning record of his artistic practice.

Neale also has given generously of his time and energy to James Reid-Cunningham, whose introductory essay, drawing extensively from a recent interview with Neale, provides an engaging point of entry for the book historian and the book lover alike. Reid-Cunningham is a bookbinder with a thirty-year career as a designer binder, conservator, and book historian. Trained as a book artist, Reid-Cunningham spent over two decades as a conservator at the Graduate School of Design at Harvard University and at the Boston Athenaeum, where he served as deputy director from 2013 to 2015. He continues to exhibit works nationally and internationally, and to teach, lecture, and write about the history of bookbinding while serving as the proprietor of Hematite Press and Wages of Fear, small presses specializing in limited editions and designer bindings. In his essay, Reid-Cunningham outlines the development of designer bookbinding during the twentieth century and relates Albert's collection of artistic bindings to developments in bookbinding structures and styles across almost two millennia. As a practic-

The Taming of the Shrew from *Shakespeare's Works* (New York: Knickerbocker Leather and Novelty Company, ca. 1910), bound by Jenni Grey, 2006.

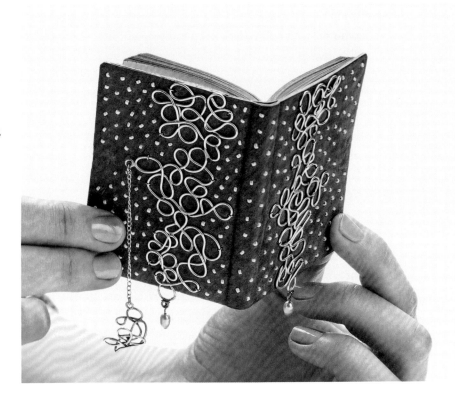

ing designer binder himself, he is uniquely qualified to discuss the central challenge of designer bookbinding: balancing art and craft.

In producing a book that so beautifully contextualizes this discipline, Elisabeth has worked with the Center's former Associate Director of Exhibitions and Publications, Eleanor Hughes (now Deputy Director for Art & Program at the Walters Art Museum, Baltimore), and her team, particularly Nathan Flis, Acting Head of Exhibitions and Publications, and A. Robin Hoffman, Assistant Curator of Exhibitions and Publications, who took over the project after Eleanor's departure; and Miko McGinty, designer, and her team, including Rita Jules and Claire Bidwell. We thank the Center's Head of Design, Lyn Bell Rose, and our installation team, led by Richard Johnson, for their collaborative efforts in producing an exhibition that makes a virtue of the objects' diminutive scale. We also acknowledge Sarah Welcome,

Senior Curatorial Assistant in the Department of Rare Books and Manuscripts, who provided invaluable assistance to Elisabeth and to the project in general. Finally, we are grateful for the support of the Wendy's Company, whose generosity has supported the production of this beautiful publication.

The designer-bound miniature books in the collection of Neale and Margaret Albert simultaneously prompt us to step forward, to examine the details of these small works more closely, and to step back, to survey the full, rich history of the book arts. That tradition encompasses figures as diverse as William Shakespeare and Cole Porter, who received his bachelor's degree from Yale University in 1913. Porter was inspired by Shakespeare's *The Taming of the Shrew* to write the musical *Kiss Me, Kate* and to refer to his poetic predecessor as "the poet of them all" in one of the production's songs, entitled "Brush Up Your Shakespeare." The centerpiece of this exhibition is a group of nearly forty copies of a miniature edition, published by Albert at his Piccolo Press, of illustrated lyrics to this song. Opening near the 125th anniversary of Cole Porter's birthday, the exhibition provides a fitting occasion to appreciate both the artists and the patrons who continuously reinvigorate the "sister arts" of Great Britain through literary and visual innovation.

Amy Meyers
Director, Yale Center for British Art

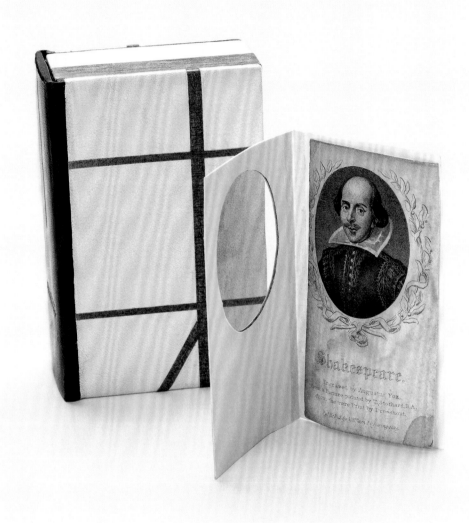

The Plays of Shakespeare, vol. 1 (London: William Pickering, 1825), bound by Johanna Röjgård, 2007.

"The Poet of Them All": William Shakespeare and Miniature Designer Bindings from the Collection of Neale and Margaret Albert

Elisabeth R. Fairman

The exhibition *"The Poet of Them All"* has at its heart Neale and Margaret Albert's collection of artistically and imaginatively bound miniature editions of the plays and sonnets of William Shakespeare, and works inspired by them. Each of these diminutive books measures less than three inches high and is, in its own way, extraordinary. The exhibition and the present accompanying publication explore these books in depth. They also provide a glimpse into the heart and mind of a true collector, one who does not merely accumulate things for their own sake but actively engages in the process of creating a work of art and intuitively understands the resonance that certain objects can evoke. Neale Albert wrote recently:

> When I think about the books in this exhibition, I feel that I have created something wonderful. They would not exist if I had not commissioned them. Take the books in my first collection [of commissioned miniature bindings], which I donated to the Grolier Club in New York in memory of my daughter Deborah, who died in 2008. I don't own them anymore. But that doesn't matter. They are still mine. When I sit in the room where they are now permanently housed, I feel close to her.[1]

For his collection of miniature books focused on Shakespeare, formed over the past ten years or so, Albert commissioned some of the most talented designer bookbinders working today to create something special for the cover of each one. He gave all of them "free rein," a term used by more than one of the binders in correspondence about Albert's role as patron. In turn, Albert considers them artists, and he "never [tells] an artist what to do." He challenges them to produce their best work but otherwise gives no instructions. He wrote to one artist, slightly tongue-in-cheek, "My only instructions are to make this the finest binding you have ever done. How is that for pressure?" Indeed, every binder, whether using leather, paper, cloth, wood, metal, or acrylic, rose to the occasion and created a distinctive work of art.

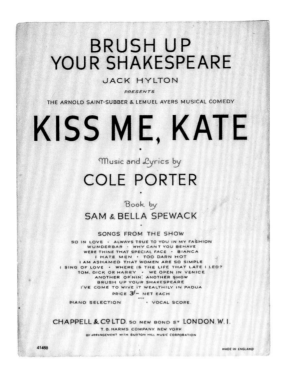

Figure 1. The title page to the sheet music for Cole Porter's song "Brush Up Your Shake-speare," from his musical *Kiss Me, Kate*, first produced on Broadway in 1948.

"The Poet of Them All," the main title of the exhibition, is taken from a line in the song "Brush Up Your Shakespeare," from Cole Porter's lively musical *Kiss Me, Kate*. First produced on Broadway in 1948, it tells the story of a traveling company of actors performing Shakespeare's *The Taming of the Shrew* (fig. 1). At the center of the Alberts' collection, and of this exhibition, are thirty-nine copies of a miniature book containing the lyrics and music to that song, with drawings by Seymour Chwast. Published by Albert's Piccolo Press in 2009, the book was designed by Leonard Seastone, and fifty copies were printed in letterpress at his Tideline Press in New York City; most were subsequently bound by different designer bookbinders (fig. 2).

Seastone has written that he designed the sheets to allow the binders as much flexibility as possible. His design accommodated those who, for example, might want to bind the books in an accordion style (where the sheets are folded back and forth like a concertina and glued together, with the endsheets attached to the front and back boards; fig. 3).[2] He made this approach and others possible by printing the book "in double-page spreads as a means of avoiding excessive difficulty in minute tolerances of registering the printed images across the gutter during the binding process."[3] Seastone wanted the binders to have the freedom to bind the books in any way they chose.

Figure 2. The title page to *Brush Up Your Shakespeare*, with illustrations by Seymour Chwast. Designed and printed by Leonard Seastone (New York: Piccolo Press, 2009), bound by Bayntun-Riviere, 2011.

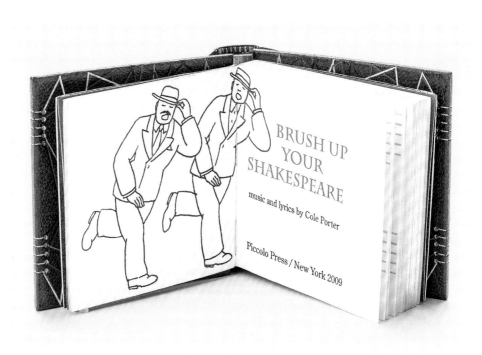

Figure 3. *Brush Up Your Shakespeare* (New York: Piccolo Press, 2009), bound by Hannah Brown, 2010.

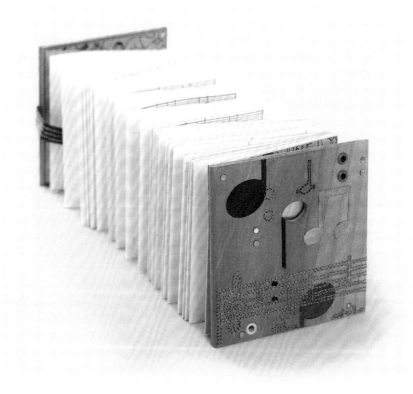

Albert supplied the sheets to thirty-nine designer binders he knew, primarily in the United Kingdom and the United States but also in Argentina, Canada, the Czech Republic, France, and Israel. The unique artistic bindings that resulted are described and illustrated in the first section of this publication. And, as the book historian James Reid-Cunningham notes (and discusses in depth in his essay): "Although the folded sheets were sometimes joined as an accordion, in many cases they were not. In some instances they were glued at the spine, just like a conventional book. There is an enormous variety of methods used to attach the leaves in the collection."[4] As will be seen, the cover designs are just as varied.

The collector also commissioned new artistic bindings for two older miniature sets of Shakespeare's works previously bound in their original plain, and somewhat shabby, leather covers: a twenty-four-volume set, published by the Knickerbocker Leather and Novelty Company in New York City about 1910; and *The Plays of Shakespeare*, issued in nine volumes by William Pickering in London in 1825. The binders of these books come from Greece, Italy, Spain, and Sweden, reflecting Albert's worldwide reach—and the list does not take into account binders who were trained in other countries (such as Germany and Japan) but who now practice in the United States or the United Kingdom.

Figure 4. *The Plays of Shakespeare*, vol. III (London: William Pickering, 1825) in its original plain binding.

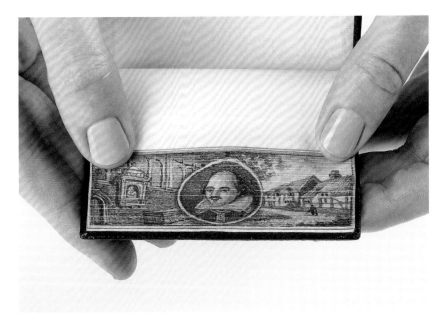

Figure 5. *The Plays of William Shakespeare*, vol. III (London: William Pickering, 1825). A portrait of William Shakespeare in pen and ink and watercolor, ca. 1825, revealed only when the leaves of the book's fore-edge are fanned.

Like the binders of *Brush Up Your Shakespeare*, many of these artists have provided illuminating remarks about their designs and working methods. A few binders retained some details of the original, such as the sewing or the gilt edges, yet the idea was not to restore or conserve the original binding but rather to create something altogether new.

Albert has an additional book from the Pickering set in its original binding, another copy of volume III of the same edition (fig. 4). This one has not been rebound because it is already special in its own way: it includes a secret image known as a fore-edge painting, one that is only revealed when the leaves of the book's fore-edge are fanned (fig. 5). Traditionally, and as was done in this case, the painting would have been made while the leaves were spread so that when the book is closed, the portrait of Shakespeare is not visible.

Some binders represented in Albert's collection decorate the edges of the pages of their books in a similar fashion, but the illustration is applied while the book is closed so that it is always visible. While they are not so secret, these design elements invite the viewer to look even more closely at every aspect of the small and meticulously designed works of art. One discovers, for example, a portrait of the title character from Shakespeare's *Titus Andronicus* on the top edge of Tom McEwan's binding for volume VIII of the Pickering set (fig. 6), or notices the dancer on the fore-edge of Ann Tout's *Brush Up* binding (fig. 7). She added this component to evoke something more abstract

Figure 6. *The Plays of Shakespeare*, vol. VIII (London: William Pickering, 1825), with top and fore-edge decorations by Tom McEwan, 2011.

Figure 7. *Brush Up Your Shakespeare* (New York: Piccolo Press, 2009), bound by Ann Tout, 2014, with her fore-edge drawing.

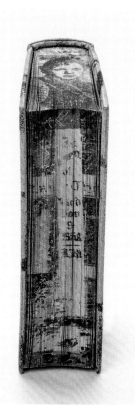

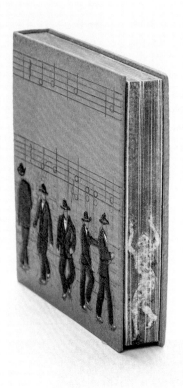

than McEwan, noting: "I felt a stage atmosphere was needed, and used graphite for the edges to create a fore-edge painting of a dancer. I think it bestowed a light and shadowy backstage quality to the binding."[5] As a practicing designer bookbinder himself, Reid-Cunningham is acutely sensitive to the idea that these "miniature books contain small universes that draw the viewer in and provide an intense focus that is absent in a larger format."

The last of the following sections includes other examples of unique miniature designer-bound works. Among these are several sets of Shakespeare's works (one measuring just over two inches high, with each of its forty volumes bound in a different artistic binding by Jana Přibíková); a specially commissioned manuscript copy of *Brush Up Your Shakespeare* bound by Donald Glaister, with calligraphy and illuminations by Suzanne Moore; and works by Susan Allix, Gabrielle Fox, and others that feature songs or quotations based on particular themes in Shakespeare's plays. Several full-sized designer bindings of Shakespeare's plays from the Alberts' collection complement the miniature bindings in this section. Also featured here are a

Figure 8. Tim
Gosling, model of
the Globe Theatre,
2015, constructed
of sycamore and
harewood, with
silver, gold, leather,
platinum, and star
sapphire.

number of small bookcases, each housing its own set of works by Shakespeare in miniature, as well as two scale models of the playwright's Globe Theatre. Albert commissioned several of the pieces from the London bespoke-furniture designer Tim Gosling, another relationship he particularly relishes: "When I commission a binder, I never give instructions," Albert declares. "I'm not a binder. But when I commission a piece from Tim Gosling, I am usually a part of the process. My ideas and his ideas merge into something wonderful. We both get pleasure from this collaboration" (fig. 8).[6]

The binders represented in the Alberts' collection all express their admiration for Neale, and they acknowledge the role he plays in the miniature book world. Besides having served two terms as president of the Miniature Book Society, he actively supports designer binders generally. In 2014 he was elected an honorary fellow of Designer Bookbinders, the principal society in Great Britain devoted to artistic bookbinding. Many voice their affection for him openly. "I wish there were more Neale Alberts in the world," Susan Allix

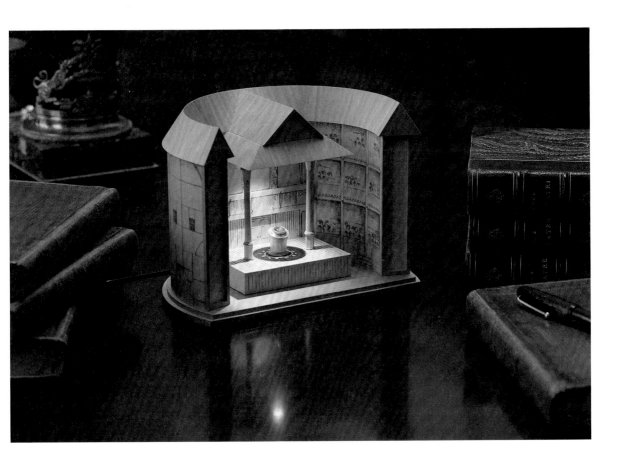

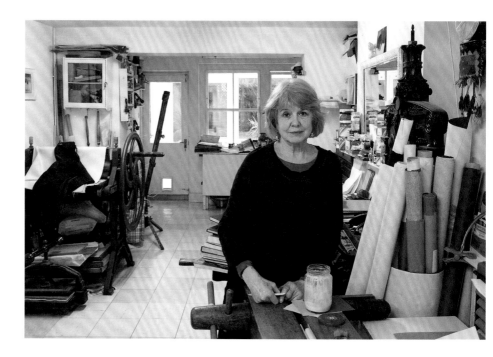

Figure 9. Susan Allix in her studio in London, England, 2015.

writes. "It is a pleasure to know someone who values and trusts a creative ability to the extent that he can stand back and allow a binding to happen" (fig. 9).[7]

Other designer binders mention the creative freedom Albert allowed them by omitting time constraints from his commissions. He believes they should take as much time as they need, whether it is one year or six. (Indeed, one Pickering binding is still forthcoming.) He is a patient man who recognizes that most collectors who love books and art are not; he thinks they have good intentions but really just "want to be able to buy something and take it home right away. Commissioning something takes too much time for them."[8] The binder Angela James believes that Albert's commissions are unquestionably the best kind: "There are no demands, no restrictions, and usually no time limits, which gives one the freedom to develop a binding the binder feels comfortable with and which, obviously, one hopes the recipient will enjoy."[9]

Figure 10. Michael Wilcox in his studio in Ontario, Canada, 2015.

The binder Michael Wilcox touches upon another important characteristic of Albert's commissions: "I imagine a large part of the excitement felt in commissioning a designer binding lies in not knowing what the result will be—a bit like gambling" (fig. 10).[10] This idea of the risks and rewards involved in commissioning designer bindings resonates with Albert, and he has mentioned its appeal more than once. While he may not like every binding in the collection equally—he definitely has his favorites—he says he always relishes the sense of anticipation before he opens the package and sees the book. And, he adds, he is able to re-create that enjoyment every time he takes the book off the shelf and removes it from its box (fig. 11). For him, there is no question that the whole exercise is worth the risk, one that the artists acknowledge as well. As the binder Annette Friedrich notes:

> Commissioned designer bindings are quite a unique challenge.
> It is not unusual to have a carte blanche for the design. However,

there is always a small yet distinct flicker of awareness for "the other" in the back of one's mind. The book, for one, is important to the client, important enough to go to the trouble of having it bound and adorned. And although the client "knows" the binder's work, the points of anticipation and fulfillment are months apart. A long time for change, on either side. Both accept the risk of disappointment as well as of utter delight.[11]

This two-way businesslike relationship is important, but there also may be some truth in Sün Evrard's rather cheeky explanation: "Book collectors are crazy people. Have you ever heard of any profession other than bookbinding where the client does not know what he will get, when he will get it, or how much will he pay for it? Well, he knows you, your work, and has a vague idea about your prices . . . but still."[12]

There is no question that Neale and Margaret Albert's collection of designer-bound miniature books is composed of painstakingly conceived works of art that are especially appealing because of their small scale. They help establish the illusion of a secret world in a miniature universe, one that many of us imagined as children. But this collection is more than a nostalgic

Fig. 11. Neale Albert looking at *Brush Up Your Shakespeare*, bound by Annette Friedrich, 2014.

reference to childhood, and Albert himself does not know exactly why he commissions and collects these books. His reasons may be as simple and true as the advice given by the eighteenth-century essayist Samuel Johnson to his biographer, James Boswell: "There is nothing, Sir, too little for so little a creature as man. It is by studying little things that we attain the great art of having as little misery and as much happiness as possible."[13]

Notes

1. Neale Albert, e-mail to Elisabeth Fairman, April 6, 2015.

2. For details of this binding technique, as well as others mentioned in the present publication, see Julia Miller, *Books Will Speak Plain: A Handbook for Identifying and Describing Historical Bindings* (Ann Arbor, MI: Legacy Press, 2011). For definitions of bookbinding terms, consult Matt Roberts and Don Etherington, *Bookbinding and the Conservation of Books: A Dictionary of Descriptive Terminology* (Washington, DC: Superintendent of Documents, 1994), http://cool.conservation-us.org/don.

3. Leonard Seastone, e-mail to Neale Albert, May 5, 2010. See also pp. 58–9.

4. James Reid-Cunningham, e-mail to Fairman, July 11, 2015.

5. Ann Tout, e-mail to Fairman, March 1, 2015. See also pp. 124–25.

6. Albert, e-mail to Fairman, April 6, 2015.

7. Susan Allix, e-mail to Fairman, February 20, 2015.

8. Albert, e-mail to Fairman, April 6, 2015.

9. Angela James, e-mail to Fairman, February 23, 2015.

10. Michael Wilcox, letter to Fairman, April 2, 2015.

11. Annette Friedrich, e-mail to Fairman, February 21, 2015.

12. Sün Evrard, e-mail to Fairman, April 20, 2015.

13. Quoted in James Boswell, *The Life of Samuel Johnson*, 2 vols. (London: Printed by H. Baldwin for C. Dilly, 1791), 1:235.

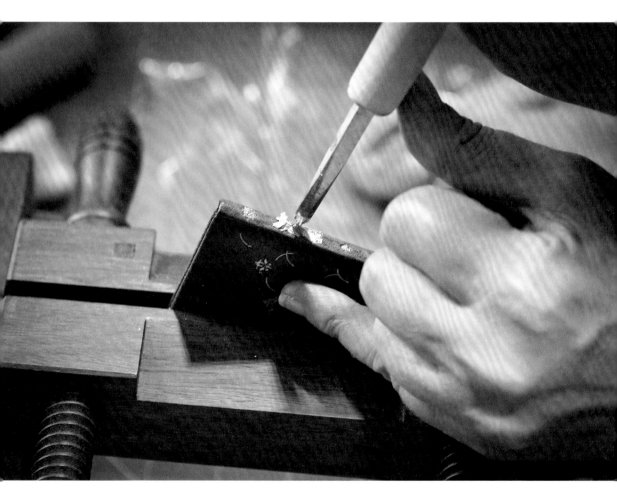

Gabrielle Fox tooling with gold leaf, *Queen Mab* (Cincinnati: Squiggle Dot Press, 2007).

Enigmatic Devices: The Art of Contemporary Designer Bookbinding

James Reid-Cunningham

Throughout history, people have decorated surfaces and embellished objects with colors, patterns, and designs. Ornamented bindings are as ancient as the codex itself, dating to late antiquity. Most of us have seen leather-bound books heavily tooled with gold leaf, but the bindings in *"The Poet of Them All"* possess a certain mystery. Why add such extravagant decoration to a book?

The collection of miniature bookbindings commissioned by Neale Albert represents the artistry of many of the finest contemporary bookbinders. The striking and unusual bindings in the collection are products of almost two thousand years of bookbinding history. There have always been both plain bindings and elaborately embellished ones, but designer binding, as it developed during the twentieth century, was never solely about decoration. Designer bindings are artistic responses to specific texts, images, and editions. The text block serves as a launching pad for the binder's imagination; the binding is transformed from its traditional role as carrier of text and images.[1]

The primary challenge of creating designer bindings is to achieve a balance between handwork and artistic vision. As a bench-trained bookbinder, I have spent more than thirty years creating designer bindings, conserving rare books and manuscripts, and fabricating sculptural book art (fig. 12). Neale Albert has commissioned me several times to create bindings for books he has collected. So I have handled many bindings, and I am still awed by the range and sophistication evident in the works included in *"The Poet of Them All."*

How did something as utilitarian as a binding come to be seen as a work of art? Until the nineteenth century, historical studies of binding focused almost exclusively on tooling patterns. By the late twentieth century, bookbinding structures began to attract scholarly attention. Book history research revealed the diversity of binding structures created over the centuries, and it encouraged artists to begin experimenting with revived structures and lost decorative techniques. The repertoire of the binder was expanded to include non-Western structures, nonadhesive books, and bindings with exposed sewing. Binders experimented with unusual materials, such as plastic, glass,

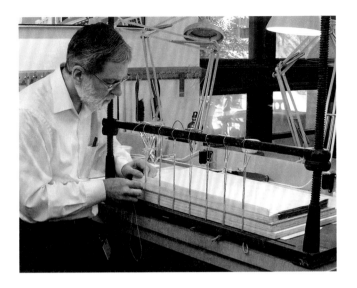

Figure 12. James Reid-Cunningham resewing an eighteenth-century atlas.

and aluminum. Almost any material can be incorporated into a binding. For designer binders today, there are fewer rules and expectations, and no rigid boundaries to define what constitutes an artistic bookbinding.

The late twentieth century saw a renaissance in all of the arts of the book: letterpress printing, papermaking, calligraphy, marbling, and bookbinding. At first glance, this revival is puzzling because it occurred just as computers and digital connectivity overwhelmed modern life. Countless scholarly conferences have debated the so-called death of the book in recent years, but the book remains stubbornly alive. People enjoy objects: we like to create them and handle them, and the more digital everyday life becomes, the greater attraction the analog holds. Designer bindings are kinetic sculptures meant to provide both pleasure and aesthetic stimulation.

The central trends and issues in designer bookbinding in the early twenty-first century are represented in Neale and Margaret Albert's collection and are on display in *"The Poet of Them All"*: the challenges of balancing art and craft; the interplay of representational imagery and typographical elements; forms of abstraction that verge on the nonobjective; the use of innovative materials and techniques; enclosures as integral elements of the book; and the integration of contemporary art styles into bookbinding. The finest designer bookbindings present the viewer with no obvious meaning, no roadmap to guide the reader's experience. They are enigmatic devices that resist comprehension.

When I commission binders, I don't tell them what to do, so they come up with things that are unique, that no one has done before.

—Neale Albert

What are we to call the books that Albert commissions? Among bookbinders, they are often called designer bindings or design bindings. The former term emphasizes the binder, while the latter focuses on the binding itself. Competitions frequently class them as "fine bindings" to distinguish them from more workaday books. A fine binding refers to a deluxe volume executed at the highest degree of skill, but often a fine binding is really just one that is heavily decorated with gold. Fine bindings are extremely difficult to execute, and few binders are equally skilled at each phase of the process: sewing, covering, tooling, and decorating. The deluxe, or fine, binding should convey the value of an individual volume or edition, the importance of the author or text, and the high quality of the materials. But otherwise, the term "fine binding" has little resonance for the book historian. Albert himself dislikes the term "designer binding," preferring to call his books "artistic" or "art" bindings because each one is, first and foremost, a work of art. However, because the term most frequently used in the field is "designer binding," it is used in this essay (and more generally throughout this publication).

The very concept of a designer binding is little known even among bibliophiles. A designer binding merges art and craft, executed to the highest levels of both, but this is just the beginning of a definition. An artist creates a designer binding using a specific text, edition, and illustrations as points of departure. Generally, designer bindings appear on small press books that are printed letterpress on fine paper with original illustrations. Such a binding is an aesthetic response to the text, reinterpreting the original without slavishly imitating it. Text and illustrations act as a catalyst for the binder. Some binders read the entire book in order to immerse themselves in the words of the text. Others may appreciate and be inspired by the style, color, or subject of the illustrations but find the text unappealing. The original text and illustrations are only a stimulus, neither an endpoint nor a limit. The best designer bindings move beyond the texts to become entirely new objects and new experiences for the viewer. Designer bookbindings are collaborations with an author, an illustrator, and a printer, even if those individuals never meet. A designer binder is rather like a musician who, rather than playing his own composition, performs a piece of music by another composer. No two

musicians interpret the same piece in the same way, and therein lies one of the great pleasures of a live concert.

Derek Hood's binding for *Brush Up Your Shakespeare* (2010) appears at first to be a mystery (fig. 13; pp. 88–9). Inset white lines outline broad shapes and provide a reference to a musical staff (or stave) on the upper cover. The lettering of the title balances the design and provides a visual anchor. Some binders create a single canvas of spine and boards, as if the book were a painting. Some focus on the upper board (the front cover), leaving the lower board (the back cover) blank. Or the lower board might be decorated with a reversed version of the upper board or a slightly simplified version of the design. Hood focuses on the upper board, with some elements spreading across the spine and onto the lower board, which is largely empty. The design is simple, crisp, and clear, essential qualities for such a tiny book. This binding, with its merger of geometric shapes and lines to convey the musical movement contained in the book, exemplifies a classic style of the late twentieth and early twenty-first centuries.

Figure 13. *Brush Up Your Shakespeare*, (New York: Piccolo Press, 2009), bound by Derek Hood, 2010.

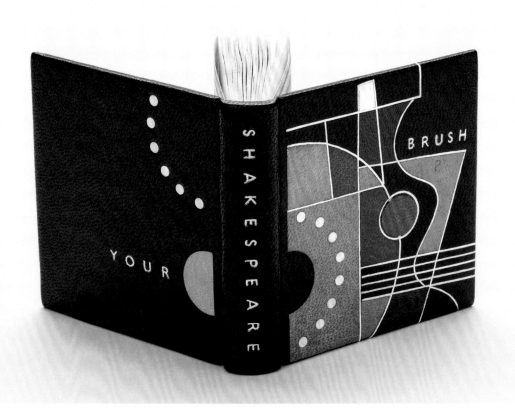

People think that collecting is about having things. Collecting is about finding something, and learning about it. You acquire works of art because you can't live without them.

—Neale Albert

Neale Albert's collection of bindings of Shakespeare texts is the culmination of a lifetime of collecting works of art. Born and raised in New York City, he attended a military academy—despite his claim that he was not a troublesome child. He graduated from Princeton University and attended law school at Yale University. Upon graduation, he joined the law firm of Paul, Weiss, Rifkind, Wharton & Garrison, where he remained throughout his career as a corporate lawyer, handling mergers and acquisitions. Albert served as the sole curator of the firm's art collection for more than forty years; it now totals fourteen hundred works, including paintings, prints, watercolors, and especially photographs. An avid photographer himself, he gravitated toward representing many leading photographers of the last fifty years, such as Robert Frank, Lee Friedlander, and Irving Penn. He is also the proprietor of Piccolo Press, a publisher of limited editions in miniature.

Albert believes wholeheartedly that one is either a collector or not a collector. He cannot remember when he was not a collector. What does he collect? Brass snuffboxes. Walking sticks with globe-shaped handles. Coalport china. Trompe l'oeil ceramics. Dollhouse furniture. Miniature models of period rooms. Contemporary paintings. Photography and photographic books. Above all else, he collects miniature books. A truly eclectic collector, Albert is drawn to fascinating and beautiful objects, be they paintings, books, or decorative art. He is especially enamored of handmade works redolent of their creators and periods.

Albert handles his books with ease and familiarity, not as though they are fragile or delicate or precious. He believes they should be touched and experienced not solely by reading but also by other senses. After he asked me to bind a work of Shakespeare for his collection, we met at a reception, where he casually removed the book in question from his jacket pocket and handed it to me in the crowded room. It is clear, however, that what appears to be an offhand attitude actually demonstrates his enchantment with these distinctive volumes and his desire to share the pleasure they provide.

I never give the binders instructions about what to do. I don't
tell them what I want. I never know what will arrive in the mail.
—Neale Albert

Albert's relationship with bookbinders is equally casual. He commissions
designer bindings by supplying each binder with a text block. He asks
nothing specific of the artist—no demands and no requirements for particular materials or styles. Not only does he not interfere, he also does not even
want to know what the binder is going to do. Neale Albert's collecting is the
purest form of patronage: he understands that a collector cannot create these
objects himself, but he can support those who do. And he can thoroughly
enjoy each new acquisition. Every binding is a surprise.

Why miniature books? Do they not seem almost frivolous, even silly—
something for children or possibly a suitable birthday gift for an elderly aunt?
I am not sure there is an answer to this question, even for Albert. He claims
that his passion for miniatures is a result of living in a two-bedroom co-op
apartment in New York City; that is, space constraints limit his collecting to
small objects and paintings that fit onto his walls. Miniature-book enthusiasts often cannot articulate the attraction, perhaps because some things
worthy of infatuation transcend explanation. Whatever the reasons for the
affinity, miniature books contain small universes that draw the viewer in and
provide an intense focus that is absent in a larger format. Miniature books
create a secret world.

A true miniature book is less than three inches tall. The earliest known
miniature books are Sumerian cuneiform clay tablets from the fourth millennium BCE. Medieval devotional texts were sometimes written on parchment
in miniature, and printed miniatures appeared soon after the development in
Europe of printing with movable type, in the fifteenth century. Heretical
religious texts were printed in miniature so they could easily be hidden and
avoid the attention of censors. The miniature format was also suitable for
secretive revolutionary political tracts. Eighteenth- and nineteenth-century
almanacs were printed in miniature for the sake of convenience. In the United
States, miniature books were published for the educational and religious
edification of children during the nineteenth century.

Miniature books became increasingly popular during the twentieth
century and were printed on almost every subject and in many languages. In
the late twentieth century there were several attempts to create the "world's
smallest book" using photographic techniques; sometimes a magnifier was

included. At times it appeared that anything could be considered a miniature book, even a laser-etched text on the head of a pin. This mindless competition for smallness resulted in curiosities for collectors, with little relation to the history of actual books.

Miniatures pose extraordinary structural challenges for a bookbinder. They often do not open well because paper that flexes easily in a large sheet is significantly stiffer in a small format. The pages turn with difficulty, and once opened, miniature books often do not close because the boards are simply too light for gravity to press them back in place. The structural complexity of miniatures is one reason why so many bookbinders enjoy Albert's commissions: binding a quarto or an octavo is straightforward, but miniatures stretch the binder's craft skills to the limit.

> Shakespeare is part of the education that every person should have in life. Everyone knows the characters and stories. I wasn't particularly a Shakespeare enthusiast, so this collection is an historical accident. Once I started, I couldn't stop.
> —Neale Albert

Bindings of *Brush Up Your Shakespeare*, a miniature book designed and printed by Leonard Seastone and published by Neale Albert's Piccolo Press in 2009, form the centerpiece of *"The Poet of Them All."* The text is song lyrics by Cole Porter for the Broadway musical produced in 1948, *Kiss Me, Kate* (itself derived from Shakespeare's *The Taming of the Shrew*), enlivened by musical staves and notes and line drawings by Seymour Chwast of dancing men in suits, ties, and hats. The entire ensemble reflects Albert's lifelong interest in art, music, and literature. The Piccolo Press books have been augmented with two complete historical sets of Shakespeare: *Shakespeare's Works*, published in twenty-four volumes by the Knickerbocker Leather and Novelty Company (New York, ca. 1910) and *The Plays of Shakespeare*, issued in nine volumes by William Pickering (London, 1825). A different bookbinder has been commissioned by Albert to rebind each volume of both sets. Although it is common for a single bookbinder to bind a multivolume set, it is highly unusual to have a different artist execute each volume of a single set in disparate materials and styles. The diversity of the bindings on display may appear visually jarring at first, but as a group they are extraordinary, representing the trends in early twenty-first-century designer bookbinding:

the revival of historical structures and techniques, the use of innovative materials, and the integration of contemporary art styles.

Designer bookbindings are the culmination of centuries of developments in the art of the book. A codex is the book structure most familiar to contemporary readers, with leaves that are attached at the spine edge and protected by front and back covers. The codex as a book format replaced the papyrus scroll during late antiquity. Coptic Christians in Egypt created the earliest surviving codices from the second to the fifth centuries CE. Coptic bindings were covered in tanned leather and decorated with pigments, inks, gold paint, latticework, and pierced leather that revealed the boards beneath. Many featured blind tooling, an embellishment achieved by pressing a heated metal tool into damp leather to form lines, shapes, and devices; this was the predominant decorative technique for the first thousand years of the codex.

During the Middle Ages, religious texts were adorned with so-called treasure bindings of gold or silver covers inset with jewels and ivory, sometimes incorporating pictorial scenes or images of religious figures. During the early modern period, embroidered bindings were popular, but because they are very fragile, few have survived. Tooling with gold leaf appeared in Europe in the fifteenth century, and it quickly became the predominant decorative technique for deluxe bindings. Gold tooling accented areas of colored leather to create striking visual effects, and by the seventeenth century, collectors coveted books tooled overall with dense symmetrical patterns of gold. Because traditional gold tooling is a difficult technique to do well, fine tooling has long been the sign of a master bookbinder.

In 1785 William Edwards of Halifax patented a novel method for protecting a painted portrait or scene under transparent vellum so that the image would not rub off during handling (fig. 14). Reacting to the increasing mechanization of book production during the second half of the nineteenth century, the Arts and Crafts movement emphasized the revival of such traditional craft skills and began the gradual advance toward creating bindings that related visually to a book's contents. All these trends and techniques have survived into the twenty-first century and are evident in *"The Poet of Them All."*

> I'm not a connoisseur of bindings as such. What interests me is the artistic vision of the binder.
>
> —Neale Albert

Figure 14. Binding by William Edwards of Halifax, ca. 1785, from Horace Walpole, *Anecdotes of Painting in England* (Strawberry Hill, England: Printed by Thomas Farmer, 1780). Yale Center for British Art, Paul Mellon Collection.

Bound in tooled vellum, with pen-and-ink portrait of William Hogarth on front cover.

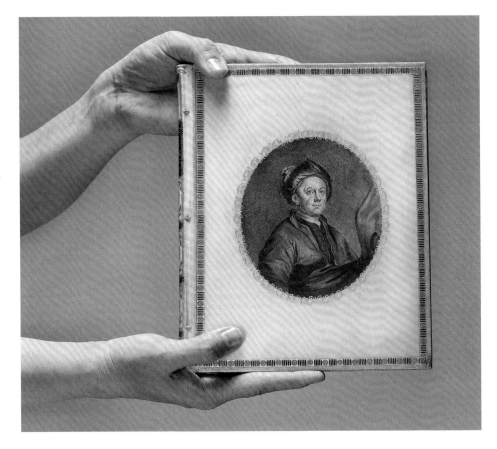

Designer bookbindings developed during the twentieth century, especially in the Art Deco period of the 1920s and 1930s. French artists such as Rose Adler (1890–1959), Pierre Legrain (1889–1929), and Paul Bonet (1889–1971) created bindings for *livres d'artiste*, the luxurious printed books illustrated by prominent European artists and published in Paris (fig. 15). Initially, Art Deco binders used geometric shapes and letters to pattern the covers in a machine-age aesthetic based on sleek mechanical forms, belying the extraordinary handcraft of their bindings. Eventually, they introduced contemporary art styles such as Cubism and surrealism into bookbinding. The results contrast a cubistic analysis of form with a surrealistic freedom of imagination. Unfortunately, this decorative styling often revealed an ignorance of the art movements the bookbinders were mimicking. Later binders followed their lead, borrowing elements of Dada, Constructivism, expressionism, abstraction, Fluxus, and almost every other twentieth-century art movement.

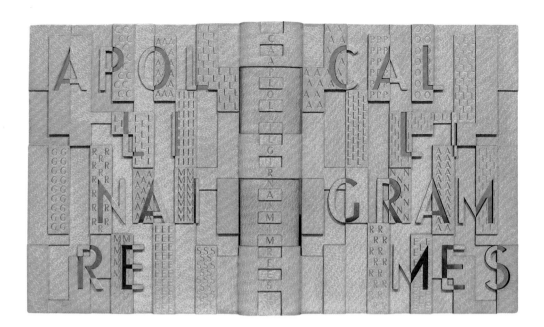

Figure 15. Binding
by Paul Bonet, 1943,
from Guillaume
Apollinaire (text) and
Giorgio de Chirico
(lithographs),
Calligrammes (Paris:
Gallimard, 1930). Rare
Book and Special
Collections Division,
Library of Congress,
Washington, DC.

Bound in yellow goat-
skin with typograph-
ical design elements
and sculptural boards
punctured to reveal
multicolored striped
flyleaves. Titled in
palladium on the
spine, with the
author's name tooled
in blind.

The British term "designer bookbinder" originally reflected French binding practice: Art Deco binders may have trained as bookbinders, but they did not actually execute their bindings. Bonet, for example, never bound a book; he created the original maquette, or model, for the binding, but specialists did the sewing, covering, tooling, and decorating. This collaborative approach remains the French practice in the twenty-first century, and it has significantly influenced British and North American binding styles over the last hundred years. One notable difference is that most British binders perform every step in the creation of a binding.[2] Having to be equally adept at all aspects of the craft is a central challenge for a designer binder.

Edgar Mansfield (1907–96) was the dominant figure of twentieth-century British bookbinding. Trained as a sculptor, for thirty years he also was a binder who never abandoned sculpture. His books have a muscularity that references the book as a three-dimensional object in motion—a piece of kinetic sculpture—with a single design moving across both upper and lower boards and the spine (fig. 16). The strong forms and sharp contrasts impart a sense of explosive movement. Unlike conventional decorated bindings, these are expressionistic artworks meant to grab the viewer's attention. His books are tactile, with a raw physicality. Crumpled leather and deep tooling make his bindings almost topographical. Mansfield's designs possess such a strong individual style that his bindings are immediately identifiable.

Figure 16. Binding by Edgar Mansfield, 1936, from H. E. Bates (text) and Agnes Miller Parker (wood engravings), *Through the Woods: The English Woodland, April to April* (London: Victor Gollancz, 1936). Lilly Library, Indiana University, Bloomington.

Bound in undyed goatskin with recessed onlays in black, yellow, pale terracotta, brownish green, and dark green, red inlays, tooling in blind, and dark brown pigment.

Mansfield taught a generation of binders at the London College of Printing. He also wrote the single most important treatise on twentieth-century book-binding: *Modern Design in Bookbinding* (1966) was the first book in English to address the central issues of expressive art in this field. He advocated combining asymmetry with bold colors and shapes to create an emotional impact.[3] Derek Hood's binding of *Brush Up Your Shakespeare*, mentioned above, is an example showing the enduring influence of Mansfield's ideas and style. The way Hood handles forms refers to Cubist experiments, and the strong colors and interaction of shapes, spaces, and lines are suggestive of Mansfield's style. His influence is especially striking in the off-balanced energy of the curved lines, which evokes the feeling of shifting back and forth in space; the titling provides the only anchor.

Mansfield was a president of Designer Bookbinders, the principal society in Great Britain devoted to artistic bookbinding. The group evolved from the Hampstead Guild of Scribes and Bookbinders, founded in 1951; in 1955 its name was changed to the Guild of Contemporary Bookbinders, to reflect its broader mission of elevating the level of craftsmanship among British book-binders and making their work known to the wider public. The guild organized exhibitions in Britain and abroad, eventually changing its name to Designer

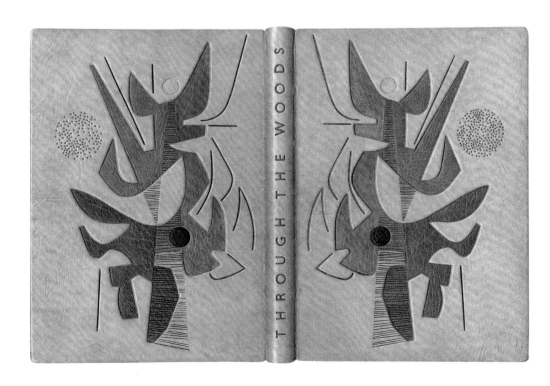

Bookbinders in 1968. Originally, members were elected, as are the fellows and licentiates today. Neale Albert was elected an honorary fellow in 2014, a title bestowed on "those who have rendered singular service to bookbinding . . . and whom the Society has thus wished to recognise and honour."[4]

Traveling exhibitions sponsored by Designer Bookbinders over the past fifty years have successfully promoted bookbinding worldwide, especially inspiring North American binders and fostering the growth of designer binding in the United States. The exhibition *Modern British Bookbindings* traveled to New York, Chicago, and Los Angeles during 1971 and 1972, offering many Americans their first exposure to designer binding. The exhibition catalogue contains two short essays by Bernard Middleton and Philip Smith that clarify their contrasting opinions about the purpose of designer binding. (Both binders are represented in the Alberts' collection.) Middleton's contribution focuses entirely on the craft of bookbinding, emphasizing the development of fine handwork over the centuries. He notes how late-nineteenth-century bookbinders split into two groups. One consisted of highly trained professionals whose work was characterized by fine finish but rather mechanical visuals; the other included talented amateurs with fewer craft skills but a more adventurous aesthetic. In his essay, Middleton contends that contemporary designer bookbinding reunites these two groups.[5] Smith's essay begins with a call to arms: "Only recently has bookbinding emerged as a field of purely artistic expression. Purely decorative bookbindings should and will be replaced by bindings evocative of the contents."[6] The bindings in *"The Poet of Them All"* are a direct result of this transformation.

Not incidentally, Philip Smith is the author of a major twentieth-century monograph on bookbinding. Published in 1974, *New Directions in Bookbinding* is an instruction manual for forward-thinking practitioners in search of new ways to express themselves through the art of the book.[7] French and German bookbinders are well represented, revealing Smith's international perspective. In addition to providing a thorough discussion of binding history, the volume also includes detailed descriptions of innovative sewing structures, endsheet design, edge treatments, headbands, and board and leaf attachment, as well as analyses of design principles suitable to the unique qualities of a bound book. *New Directions in Bookbinding* was an inspiration for a new generation of binders, myself included.

Smith's *King Lear* binding (2006) typifies his mature style (fig. 17; pp. 174–75). His bindings relate directly to the text, often incorporating scenes or human figures derived from the plot. Known for using sculptural boards,

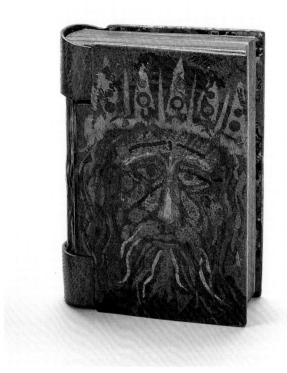

Figure 17. *King Lear* (New York: Knickerbocker Leather and Novelty Co., ca. 1910), bound by Philip Smith, 2006.

Smith developed myriad ways to handle leather, in effect creating painterly canvases across the binding and into the interior of the book. His bindings have a pictorial quality, with expressive imagery built of layers of multicolored leathers that are stained, distressed, pared tissue-paper thin, laminated, and then sectioned until they look like marbling.

Smith's virtuoso touch is immediately identifiable, but his binding on *Brush Up Your Shakespeare* (2011) is uncharacteristic of the style that has dominated his work for sixty years (fig. 18; pp. 116–17). For example, the palette is limited compared to the riot of color he usually employs. While Smith's *King Lear* has the appearance of a traditional book, his *Brush Up* is unconventional, with the boards extending well beyond the text block. The sketch from his working notebook shown here clearly illustrates his intentions (fig. 19). Unevenly shaped edges of the boards at the spine allow the boards to mesh as one when the book is opened, producing the effect of a single canvas. The circular forms on the two boards bear little apparent relation to one another or to the lyrics and illustrations of *Brush Up Your*

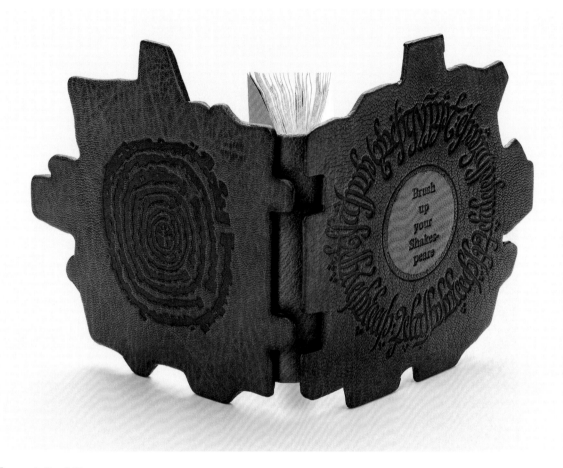

Figure 18. *Brush Up
Your Shakespeare*
(New York: Piccolo
Press, 2009) bound
by Philip Smith, 2011.

OPPOSITE:
Figure 19. Philip
Smith, working
notebook with
binding designs,
2012. Collection
of Philip Smith.

BRUSH UP YOUR SHAKESPEARE
NEALE ALBERT

2011
28·DEC
2012
4 JAN

· 23 JAN
↓
12 March

BRUSH UP YOUR SHAKESPEARE

WORK·ON·BOARDS + PARING·LEATHER
cut out pared leather for boards. FIT leather to BOARDS
loosely + DRAW ROUND THE EDGE OF. BOARDS ON FRONT &
BACK of leather ready for covering (or for onlaying
before covering if this is decided) [NOTE: RED GOATSKIN]

infill boards of small RED BINDING
pare BLUE goatskin made to over shaped boards.
infill the boards, pare blue leather (goatskin) + cover
both boards + infill the boards with same thickness
card + cover _second side of board_ (blue goatskin)

6

10
2
6
2

BOX LINING

14 MARCH
18 MARCH

pare leather + cover inside of board.
OF 'OUTER' BLUE BOARD.

FRONT
INFILL
8·3·2012

8
5

15 APRIL
16 APRIL
17 APRIL

LINE BOX EDGES WITH BLUE FELT

MAKING·UP·BOX SIDES + END PIECES
GLUE ON SIDES + BACK, then glue
the 'TOP SIDE TO/THE GLUED EDGES) the
sides + top. place a weight to the upper
'lid 'side + leave to dry hard. THIS IS A
SLIP CASE CONTAINER.

3

FELT LINED
WITH
"CONNOISSEUR"
PAPER

TEST PIECE
for TITLE
LABEL S.

Brush
up
your
Shakes-
peare

26
APRIL
24/25 APRIL
28 MAR
2012→

B
INFILL
BACK

453
4
ACTUAL
TITLE PIECES
STAMPED MUCH
DARKER IMPRESSION.

3·MAY

3¾

COST OF DELIVERY
by FEDEX £43·50

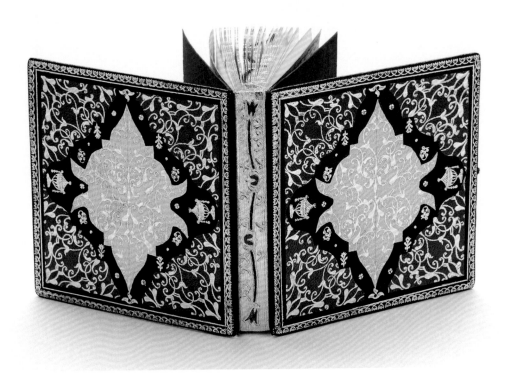

Figure 20. *Brush Up Your Shakespeare*, (New York: Piccolo Press, 2009) bound by James Brockman, 2012.

Shakespeare. This binding represents a completely new direction taken by a master craftsman. Its meaning is obscure.

Many historical binding structures have been revived during the past few decades. James Brockman's *Brush Up Your Shakespeare* (2012) is called a "backless binding": the book appears to have no spine where titling and raised bands normally would appear (fig. 20; p. 66). This optical illusion is the result of gluing leaves together at the spine and decorating them in the same manner as the other three edges. Probably because the structure is so susceptible to damage, relatively few backless bindings survive; careless handling easily breaks them. A small brass rod is embedded in the fore-edge (the outer vertical edge) of the upper board of Brockman's binding, and a note in the enclosure informs the reader that the book opens on the side with the rod. Dating to the seventeenth century, backless bindings are also known as "tease" bindings because they confound the reader's expectations of what a book is and how it should be handled. Among the oddest structures in the long history of bookbinding, the backless binding is akin to a parlor trick, an amusement meant to grace a collector's coffee table.

Tooled in the manner of deluxe bindings of the past, James Brockman's masterful example features a dense accumulation of detail. Except for the flowers, the design is almost entirely abstract. The interplay of the shapes of colored leathers overlaid with flowers and vines creates the illusion that the binding pulsates, moving forward and backward in space. The object is a technical and visual tour de force that refers to past styles without being imitative. Should this binding be considered designed or decorated? The meaning of such an entirely abstract binding is elusive, encouraging a surrender to beauty rather than an interpretation.

Most often, binding designs combine pictorial images, typographical elements, and geometric abstractions. Contrasts dominate: ambiguity and clarity, sharp edges and a painterly appearance, symmetry and asymmetry. Many of the bindings in *"The Poet of Them All"* contain images of Shakespeare himself, of characters such as King Lear, and even of Yorick's skull from *Hamlet*. Some capture the dancing men in suits or musical staves found in Seymour Chwast's *Brush Up Your Shakespeare* illustrations. Generally speaking, however, an overreliance on representational elements appears unimaginative, even trite—for example, a binding of *Moby-Dick* that shows a whale on the cover. In other words, a purely illustrated cover is not necessarily an artistic expression.

Typographical elements help the viewer navigate the binding. Titling is a challenge on an artistic binding. Although the design may be built around the lettering, many designer bindings lack titling because letters can interrupt the visual impact of the whole. Purely abstract designs without images or lettering provide the binder with a blank canvas, but the lack of recognizable markers may obscure the relevance of the binding to the text. A continuum exists between purely representational imagery at one extreme and total abstraction at the other. Few bindings represent either extreme, and many of those in *"The Poet of Them All"* alternately combine pictorial imaging with abstract or geometric elements.

Rather than calling these books "designer bindings," I prefer to use the term "artistic binding" because these binders are artists, not designers.

—Neale Albert

The *Brush Up Your Shakespeare* (2010) by Argentine bookbinder Sol Rébora possesses a deceptively simple appearance (fig. 21; pp. 110–11). The cover

leather folds at the fore-edges to form the inner boards, and the outer text leaves are inserted between the two layers of goatskin. This elegance recalls Art Deco bindings of the 1920s and '30s, with rich materials, clear geometric shapes, and virtuoso handling of forms in motion. Five gilt lines and pierced small holes (revealing the black paper underneath) decorate the white goatskin; the gilt lines extend around the fore-edges and onto the inner boards. The sharp geometrical shapes contrast with the heavy grain of the leather. The visuals refer to the musical staff and notes in the book, but instead of being parallel, the lines careen across the boards and barely contain the dark dots. The dynamic interplay of lines and dots creates a sense of energetic movement horizontally across and into the binding. This binding feels marvelous to the touch. It carries no images or words and the viewer responds emotionally to the beauty of dynamic forms (fig. 21).

Some bindings initially look puzzling. For example, the seeming simplicity of Haein Song's *Brush Up Your Shakespeare* (2010) is misleading (fig. 22; p. 113). The binding is wholly nonrepresentational, with short, angled white lines advancing across the red ground. The two-color palette with multiple onlaid lines creates a simple aesthetic requiring patience to interpret. The colors are reversed on the interior, with red lines on a light ground. The movement of the lines is almost musical, and their gentle yet insistent procession across the

Figure 21. *Brush Up Your Shakespeare* (New York: Piccolo Press, 2009), bound by Sol Rébora, 2010.

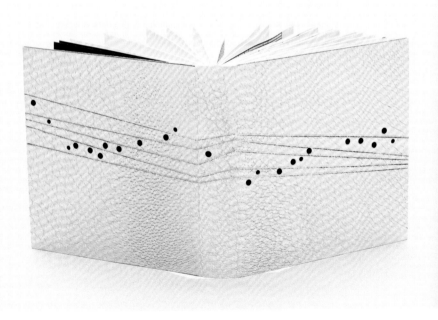

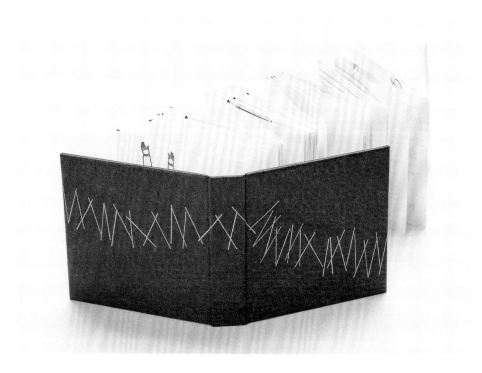

boards suggests the dancing figures of the illustrations. The binding captures
the feeling of the book without spelling out the connections. Entirely lacking
in elements such as lettering or images to provide the viewer with a basis for
interpretation, the result relies on suggestion rather than representation. The
absence of images and lettering prompts the viewer to make a purely personal
interpretation, to experience the binding in a way that perhaps
even the binder did not imagine.

If the bindings by Song and Rébora represent abstraction on the continuum
between pictorialism and nonobjectivity, Hannah Brown's *Brush Up Your
Shakespeare* (2010) occupies the center. Bound in thick wooden boards lined
with brass, it possesses a heft reminiscent of medieval bindings with exposed
wooden boards (fig. 23; pp. 68–9). The wood is pierced in the shape of musical
notes to reveal the brass beneath, and its grain imparts a natural quality to
the ensemble. Brown's aesthetic sense is entirely contemporary, without clear
precedents in binding history. Her binding, with its mixed-media composition,
has a contemporary DIY (do-it-yourself) appearance.

Elements from the illustrations and music in *Brush Up Your Shakespeare*
form a basis for the design. The multicolored threads sewn into the boards
allude to a musical stave, and they provide a distant echo of the embroidered

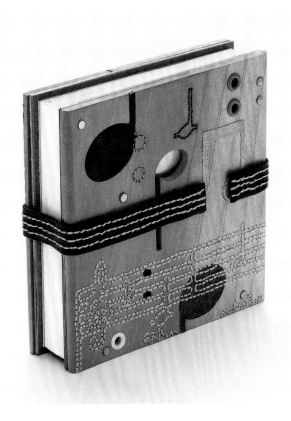

Figure 23. *Brush Up Your Shakespeare* (New York: Piccolo Press, 2009), bound by Hannah Brown, 2010.

Figure 24. Front board of Hannah Brown's *Brush Up Your Shakespeare,* in process, 2010.

bindings of early modern times. Disparate components dangle in an uncertain space, unrelated to one another: titling, musical notes in various positions and colors, punctured openings in the boards. Only the letters of the title provide a focus. At first glance, the binding appears thrown together, but a deeper aesthetic is at work. The DIY feeling exists only in the design, not in the craftsmanship. Brown's binding is actually sleek and assured in its demonstration of the late-twentieth-century movement away from traditional structures such as sewing on cords and gold-on-leather decoration. The contemporary embrace of experimentation is evident in every aspect of Brown's binding: materials, structure, and decorative techniques (fig. 24). Absent are references to past expectations regarding how a binding should look or what it should mean.

In the late twentieth century, bookbinders began to conceive of a book beyond its traditional role as carrier of text and illustrations, and to experiment with it as a three-dimensional sculpted object—meant to be seen from several viewpoints. With the concertina open, Brown's binding is indeed a

sculpture. The temptation to focus on the visuals of a designer binding can interfere with experiencing its physical qualities as sculpture.

Mark Cockram's binding of *A Midsummer Night's Dream* (2009) is an assembly of jarring parts with boards extending beyond the text block, angled away like wings (fig. 25; pp. 140–41). The surface decoration relies on disjointed transitions from color to black and white, across gold grounds and stained leathers. The black-and-white image of a woman introduces a surprising representational element. The multicolored edges swirl and invite one to fan the pages. Because this binding moves from plane to plane, it must be experienced in three dimensions. The book does not so much open as unfold, unwind, and present its constituent panels. In this experiment with spatial interrelations, Cockram challenges the reader by refusing to differentiate between inside and outside. The result deftly balances pictorialism, imagistic layering, and abstract forms.

The Pickering and Knickerbocker Shakespeare volumes in the exhibition appear, at first glance, to be a jumble of disparate styles. Interestingly, however, two binders developed superficially similar bindings. Kate Holland's binding for volume V of the Pickering set of Shakespeare's plays (fig. 26; pp. 186–87) features leather punctured with small holes in two groups across both boards; the groups meet at the spine like two armies in massed formations. The openings reveal the coloring on the boards. The contrasting green

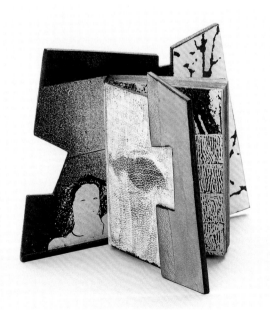

Figure 25.
A Midsummer Night's Dream (New York: Knickerbocker Leather and Novelty Company, ca. 1910), bound by Mark Cockram, 2009.

Figure 26. *The Plays
of Shakespeare*
(London: William
Pickering, 1825).
Left: volume V,
bound by Kate
Holland, 2009.
Right: volume VII,
bound by James
Reid-Cunningham,
2011.

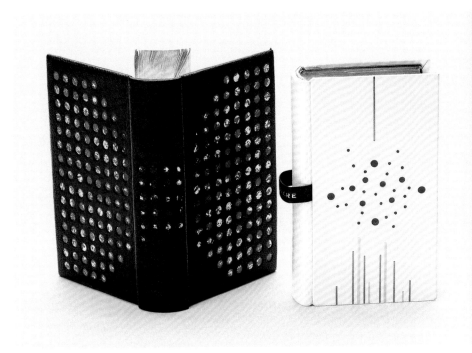

leather forms a dark ground, as blue blends to red with shimmering gold
accents. Holland combines symmetry of forms and asymmetry of colors.
My binding for volume VII of the Pickering set (fig. 26, pp. 194–95) is
similarly pierced: the vellum is tooled and then punctured to reveal
colored boards beneath. Because the characters and scenes in Shakespeare's
plays are so well known, I decided the binding could be original only if it
was abstract and geometric except for the titling. My Shakespeare is a
balance of bright circles and vertical lines, with a multiplicity of forms in
movement. The circles are the universes of Shakespeare's plays, and the
lines are the forces propelling the characters. The bold, clear colors lack
the darkness of Shakespeare's imaginary worlds; the bright and inviting
elements create uncertainty.

Holland's binding and mine are dissimilar in color, texture, and the
interplay of forms, but both use piercing to create the impression of layers of
experience. The small circular holes create movement as the central element
of the design. Furthermore, both bindings are abstract, with no representa-
tional elements to anchor the viewer's experience. Holland's decoration is
reminiscent of the pierced leather of early Coptic bindings; mine is loosely
based on vellum decorative techniques of the sixteenth and seventeenth

centuries. Even the most innovative contemporary designer bindings recall ancient antecedents.

> The better enclosures have the same level of creativity as the bindings.
>
> —Neale Albert

Boxes or other enclosures have long been used for the protection of rare books; they limit damage from handling, moisture, and dust. Enclosures for a few of the earliest known codices survive; for example, leather satchels protected Coptic bindings during storage and transport. An enclosure carries the inference of value, rarity, and scarcity. In special collections reading rooms, it is common to provide a reader with a rare book still in its enclosure. Opening the enclosure and removing the volume in front of the reader emphasizes its importance, encouraging the reader to handle it with care. The message is entirely subliminal.

All of Neale Albert's bindings have protective enclosures crafted by their creators. Some of the enclosures were constructed for more than protection, however, and serve as integral elements of the artworks. Occasionally, a binding becomes its own enclosure, as it does with Jarmila Jelena Sobota's *Brush Up Your Shakespeare* (2009)—unfolding to create a stage and form both binding

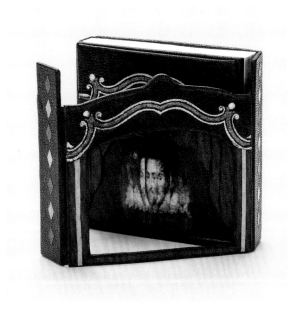

Figure 27. *Brush Up Your Shakespeare* (New York: Piccolo Press, 2009), bound by Jarmila Jelena Sobota, 2009.

Figure 28. Susan
Allix, *Flowers from
Shakespeare*, 2002.

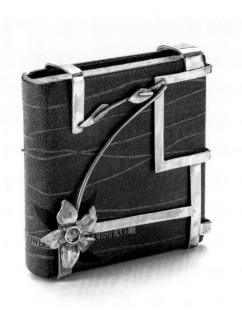

and enclosure (fig. 27; p. 119). It is a pictorial binding in a most literal sense, with Shakespeare himself looking out at the audience from between the curtains. The binding both encloses and exposes the book, drawing the viewer into the scene. Making a stage out of the binding risks appearing trite, but the virtuoso execution rescues the design. Sobota's Shakespeare is both book and box.

Designer bookbinders are drawn to building enclosures for reasons that aren't entirely clear. Over the course of the last decades of the twentieth century, binders experimented with constructing imaginative enclosures as key elements of their designs. An enclosure provides another arena for creativity, a further series of structures and surfaces where the binder can express a vision. Indeed, it may in fact be central to the reader's aesthetic experience of the book: opening the enclosure to discover a secret or a surprise. An enclosure enhances the central experience of a designer binding.

Susan Allix's *Flowers from Shakespeare* (2002) features applied leather lines spreading like vines across the binding (fig. 28; pp. 202–203). The gentle but relentless movement of the lines is mesmerizing and reminiscent of the natural world. The quiet suggestion of natural forms is barely contained by the silver enclosure. The contrast of the silver flowers with the rectangular rails creates a sense of balance with the undulating lines of the binding. The silver container hardly qualifies as an enclosure; it is more a stage set, a platform for displaying the binding. The interplay of elements between

book and container creates an experience for the viewer that neither individual object creates on its own. Neither should be seen individually; the two comprise an indissoluble whole.

Occasionally, an enclosure can overwhelm the miniature book, as is the case with Jan Sobota's *Hamlet* (2009) (fig. 29; p. 223). A cylindrical box opens to reveal a wooden stand supporting Yorick's skull, which wears a hat cocked at a jaunty angle. Hidden within the skull is the tiny book (measuring less than an inch high), bound in quarter white calfskin[8] with exposed wooden boards. The binding is finely executed, in a style common in the sixteenth century (especially in Central Europe), but it almost appears to be an afterthought. Because the binding is plain and unadorned, its container becomes the focus of attention, and the book is merely an excuse for the attention-grabbing enclosure. This object is more a reliquary than a binding.

> Who's the best binder in the world? Michael Wilcox. Of
> all the bindings on *Brush Up Your Shakespeare*, his is my favorite.
> —Neale Albert

Michael Wilcox is a consummate craftsman. His *Brush Up Your Shakespeare* (2010) combines a historical structure called a box binding with extravagant

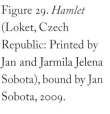

Figure 29. *Hamlet* (Loket, Czech Republic: Printed by Jan and Jarmila Jelena Sobota), bound by Jan Sobota, 2009.

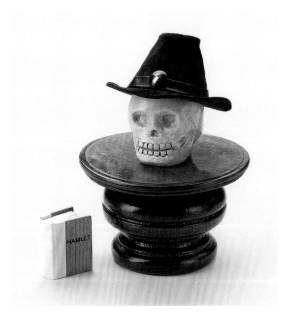

decoration in gold leaf. Both design and execution have a traditional and familiar feel, based on the application of gold tooling on colored goatskin that depicts a recognizable scene. Wilcox shows no interest in the structural and visual experimentation so evident in other bindings in "*The Poet of Them All*." Across the spectrum from the pictorial to the abstract, his approach is unequivocally pictorial.

The execution is astonishing, with clear, sharp gold tooling moving across both panels. Three dancing men on the front cover balance the three dancing women on the lower cover, all of them references to Chwast's illustrated dancers inside the book. The figures are built from simple forms of colored leather accented with gold. The leaves and vines spreading across the boards and edges lead the viewer's eye through the scene. The clarity of the imagery results from the deft use of shape and line. Wilcox's binding is so finely executed that a viewer may not realize it is a miniature book when looking at an isolated image of it. The scale becomes clear only when a reader is

Figure 30. Neale Albert holding *Brush Up Your Shakespeare* (New York: Piccolo Press, 2009), bound by Michael Wilcox, 2010.

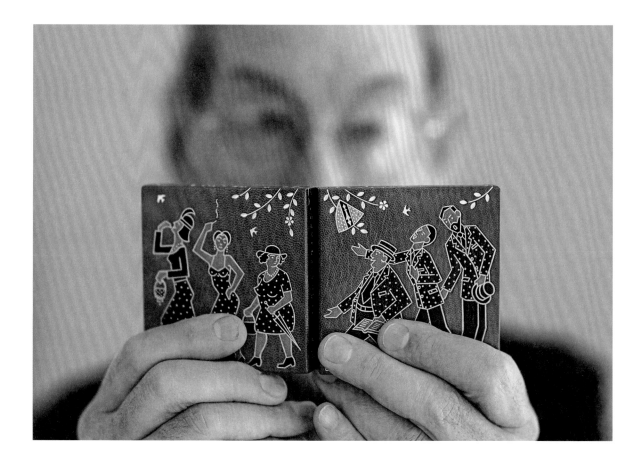

Figure 31. *Much Ado About Nothing* (New York: Knickerbocker Leather and Novelty Company, ca. 1910). bound by Sün Evrard, 2005.

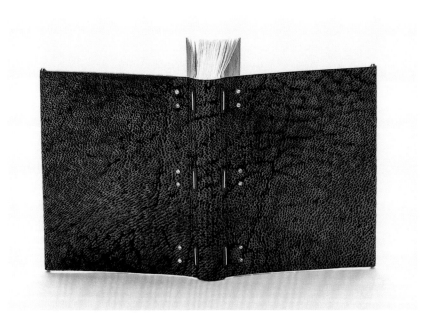

shown holding the book (fig. 30; pp. 126–27). The box binding embodies one of the central challenges of designer bookbinding: imagining a binding that functions both as a container and as an integral element of the art object. In the finest designer bindings, there is no difference between the two.

Although work by British and North American binders dominates Albert's Shakespeare collection, it also includes important examples of European binding traditions. Sün Evrard is one of the most influential teachers, theorists, and practitioners of contemporary French bookbinding. Relentlessly experimental in imagery, structure, and effect, she creates bindings that have a deceptive subtlety, a depth that reveals more with repeated viewings. A designer binding benefits from a little mystery, and should be enigmatic enough to suggest variant readings.

Some bookbindings defy description. Evrard's *Much Ado About Nothing* (2005) is so nuanced that the design almost disappears (fig. 31; pp. 144–45). The binding evokes a palimpsest, as its layered visual presentation—a flexible cover attached to wooden blocks with gold staples—is built on minimal structure. Evrard invented the staple binding, a descendant of the tacketed bindings of the late Middle Ages in which twisted vellum or cord was used to attach the text block to the cover. The leather appears distressed, suggesting cracked and smoldering lava; it was dyed using an airbrush in a blend of gray, purple, and black. Where once binders used commercially tanned

leather in a limited range of colors, airbrushing has become increasingly popular as binders seek a broader range of colors and effects. The diamonds mounted on the boards provide a distant reference to medieval treasure bindings, but otherwise this volume lacks the *horror vacui*, the "fear of empty space," that drove medieval artisans to burden surfaces with decoration. Evrard's binding is barely decorated at all.

The exquisite and quiet beauty of Evrard's *Much Ado About Nothing* expresses all the mystery of the finest designer binding. Physical descriptions, stylistic interpretations, historical perspectives, and artists' statements all have a place in outlining developments in contemporary designer bookbinding, but scholarly analysis rarely captures the essence of such evocative objects. There is a disconnection between cerebral theories of aesthetics and the vibrant, enthralling bindings in "*The Poet of Them All*." In the designer bookbindings commissioned by Neale Albert, discussion of theory and analysis should perhaps yield to a simple embrace of beauty and pleasure.

Notes

All epigraphs in this essay are quotations of Neale Albert taken from an interview with the author at Albert's New York City apartment, February 23, 2015.

1. Text block: "The body of a book, consisting of the leaves, or sections, making up the unit to be bound, rebound, or restored. It excludes all papers added by the bookbinder, including board papers, endpapers, doublures, etc." See Don Etherington, *Bookbinding and the Conservation of Books: A Dictionary of Descriptive Terminology* (Washington, DC: Superintendent of Documents, 1994), http://cool.conservation-us.org/don/dt/dt3476.html.

2. An exception to this pattern in Albert's collection is Bayntun-Riviere's 2011 binding of *Brush Up Your Shakespeare*, shown on pp. 64–5.

3. Edgar Mansfield, *Modern Design in Bookbinding* (London: Peter Owen Publishers, 1966), 95–114.

4. *Designer Bookbinders, Directory of Members* (London: Designer Bookbinders, 2012), 3.

5. Bernard Middleton, "Document 1," in *Modern British Bookbindings: An Exhibition of Modern British Bookbinding by Members of Designer Bookbinders*, exh. cat. (London: Designer Bookbinders, 1971), 9–10.

6. Philip Smith, "Document 2," in *Modern British Bookbindings*, 11.

7. Philip Smith, *New Directions in Bookbinding* (New York: Van Nostrand Reinhold, 1974).

8. Quarter calf: "A binding having the spine and a small part of the sides (about one-eighth the width of the boards) covered with leather." See Roberts and Etherington, *Bookbinding and the Conservation of Books,* http://cool.conservation-us.org/don/dt/dt2757.html.

WORKS IN THE EXHIBITION

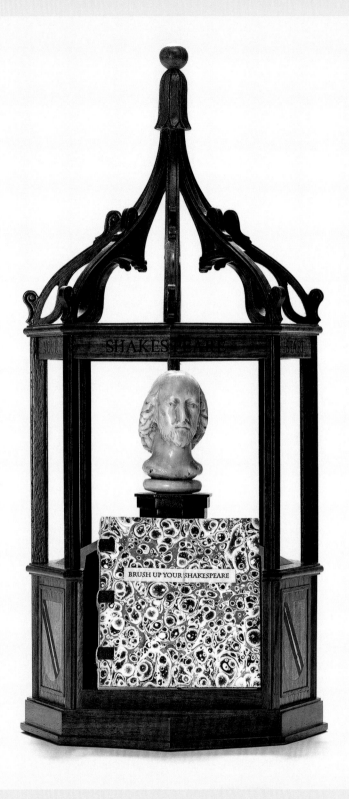

Bookstand, designed by Tim Gosling, 2010, 12½ x 5½ x 5½ inches. American black walnut, with antique ivory bust.
Stand holds *Brush Up Your Shakespeare* (New York: Piccolo Press, 2009), bound by Leonard Seastone, 2009.

BRUSH UP YOUR SHAKESPEARE

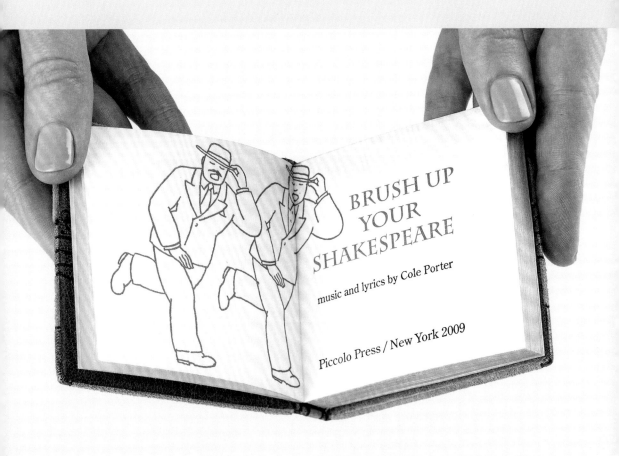

Brush Up Your Shakespeare, bound by David Sellars, 2011.

PICCOLO PRESS

BRUSH UP YOUR SHAKESPEARE
2009

Brush Up Your Shakespeare, music and lyrics by Cole Porter, illustrated by Seymour Chwast (New York, NY: Piccolo Press, 2009). Designed, printed, and bound by Leonard Seastone at Tideline Press, West Sayville, NY. Marbled paper by Jack Fitterer.

The design I had in mind for the Piccolo Press *Brush Up Your Shakespeare* had the song-and-dance gangsters hoofing across the double-page title as well as on subsequent stanza spreads. I wanted the book to open like a theater curtain. Having Seymour Chwast illustrate the performance across the book's title/stage spread did set the appropriate tone perfectly.

The musical score looms visually large by bleeding off the page, defying the miniature scale. The rhythm of the music is embraced by the different page compositions.

Yet within my design concept lies the procedural difficulty of art and text alignment across the book's gutter. Adopting this difficult staging for other binders to create a book seemed unfair: a nonalignment could trip up the

Just declaim a few lines from *Othella*

And they'll think you're a heck-uv-a fella,

If your blonde won't respond when you flatter 'er

Tell her what Tony told Cleopaterer

And if still to be shocked she pretends well,

Just remind her that *All's Well That Ends Well*

performance. The structural solution: to print the entire book in double-page spreads. . .

Within the miniature, the smallest measure looms large in other ways as well. The tiny patterns within the marbled paper that was presented as a prototype immediately won Neale Albert's approval, and so the paper marbling was commissioned from book artist/binder Jack Fitterer. . . . The text paper was handmade by St. Armand, and—most appropriately for books associated with the Bard—the printing is all letterpress. For my binding, I visited a favorite structure: the exposed spine. This binding allows the book to lie flat when open. Really, there is no room for oversized thumbs obscuring our view of Cole Porter's song-and-dance routine. Every seat in the house with an unobstructed view.

In all this was an attempt to stage the song, to book the show. And to be part of such an illustrious cast was a joyful honor. The larger world can exist more perfectly within the miniature.[1]

—Leonard Seastone

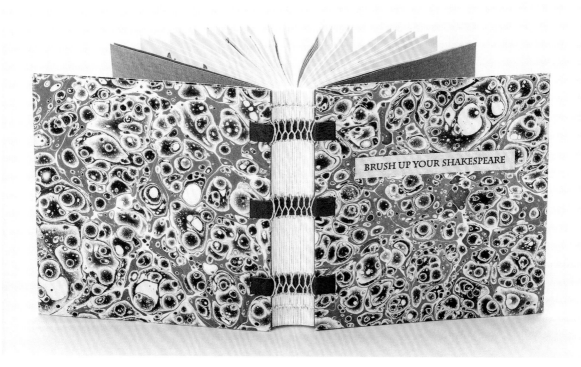

SUSAN ALLIX

2010

Bound in red and yellow goatskin, with a 1930s line-block print onlay of two figures, with title printed in letterpress in Broadway font, over black-lacquered paper on front board. Covers laced together over spine with fine red leather cord through loops attached to boards. Edges drawn with black lines. Brown fake-snakeskin endpapers. Title printed on box in black and red on yellow.

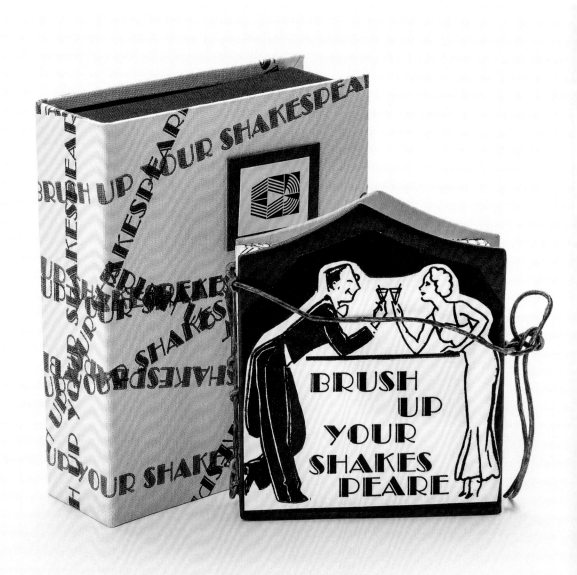

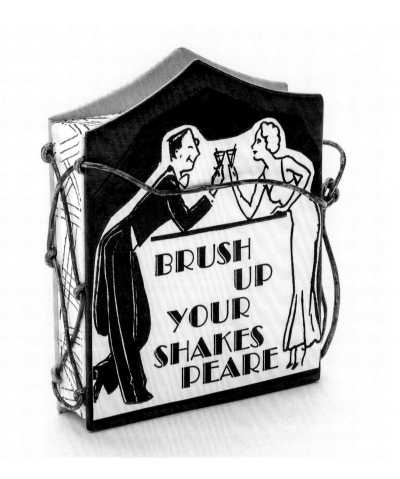

As this is a happy-go-lucky, to-and-fro book, it seemed that a little period insouciance on it would do. . . . I went for printing and tying it up rather than making a serious structure. Small worlds are like large ones, but I think one wants to avoid being precious when working on a tiny scale. My problems with miniature books have to do with flexibility, flow, opening, and closing. This may partly be caused by the inherent nature of the paper on which they are printed, the fibers not being fine and gentle enough to bend over a small area. So the more you restrict them, the more stubborn they become; once open, the pages can stick up like a porcupine, then there is not enough weight in the boards to close them well. Awareness helps to solve the problems, but this time I sidestepped by using loops and laces.[2]

—Susan Allix

GLENN BARTLEY

2012

Bound in goatskin, with hand-dyed orange and purple goatskin onlays, highlighted with blue acrylic and blind and gold tooling. Leather headbands. Colored edges. Handmade Japanese endpapers.

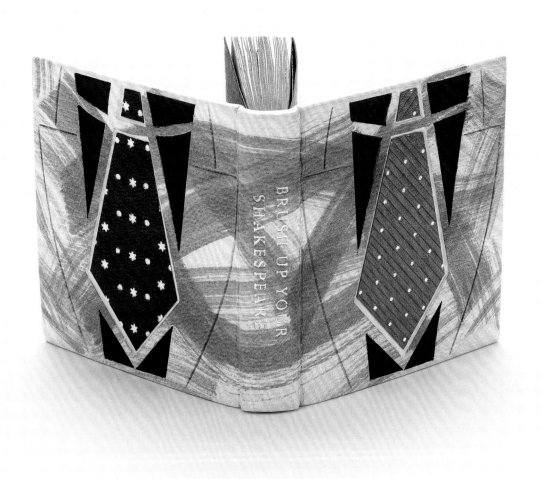

BAYNTUN-RIVIERE

2011

Bound in light-brown Harmatan goatskin, with blue oasis goatskin doublures.[3] Concertina-style text block laced into the boards. Covers and doublures tooled in gilt, palladium, and colored foil.[4] Italian marbled endpapers and blue suede flyleaves. All edges gilt.

The book was bound by a team of binders at Bayntun-Riviere, with concept, design, and covers by Spike Llewelyn; sewing by Emma Abrahams; gilding by Andrew Van Zanten; and finishing by Tony Evans.

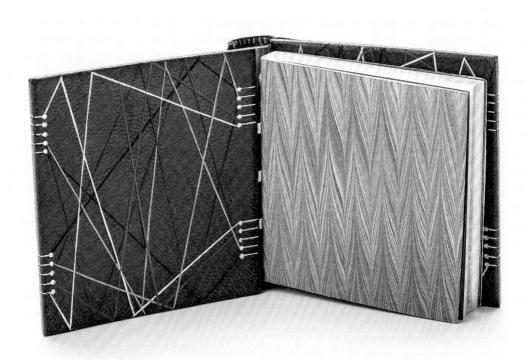

The design is drawn from the montage typography in the book and from the playful nature of the song.[5]

—Edward Bayntun-Coward

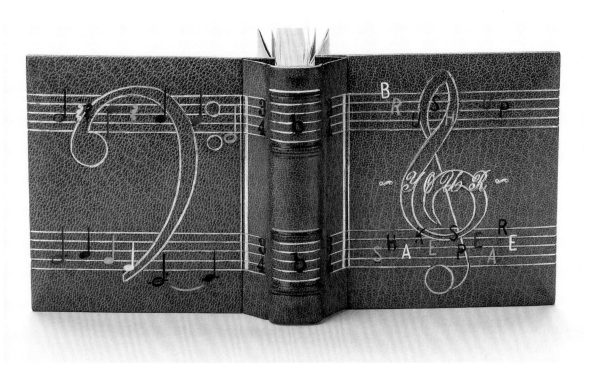

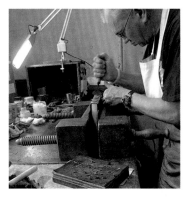

JAMES BROCKMAN

2012

Bound in black goatskin, with red and undyed goatskin onlays tooled in gold leaf. All four edges gilt with decorative tooling. Japanese and marbled endpapers.

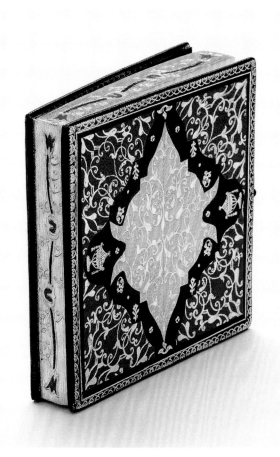

As a designer bookbinder, conservator, and restorer, I enjoy working on books from all periods. It is particularly satisfying to design and bind a modern book in an earlier style. In this case, the design is based on the backless bindings of Richard Balley, a seventeenth-century London bookbinder. I was able to improve the function of the original structure since I had conserved one of his original bindings.[6]

—James Brockman

Bound in transparent vellum over images drawn onto Japanese tissue and airbrushed. Spine covered in black calfskin, tooled in gold leaf. All edges gilt.

STUART BROCKMAN
2010

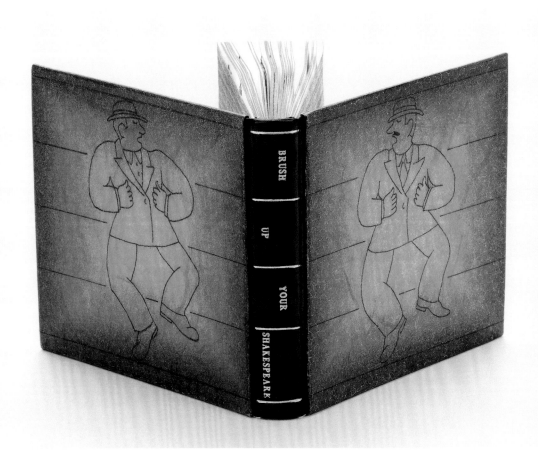

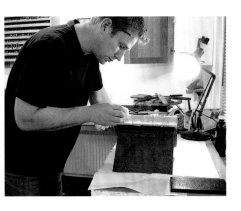

The images of the two men are from the illustrations by Seymour Chwast. The fine lines represent a musical stave, and the lettering arrangement is representative of notes of the stave.[7]

—Stuart Brockman

HANNAH BROWN

2010

Bound in wooden boards backed with lacquered brass, joined with handmade brass rivets. Images of musical notes and staves routed into the wood, with colored leather inlays. Leather-covered vellum strap with magnets keeps book closed. Hand-drawn and hand-painted with acrylics on lime-green endpapers. Edges painted in acrylic.

Wooden enclosure, with lid backed in lacquered brass and similar decoration as the binding. Title printed onto lime-green paper and sewn to top of box with gold thread. Leather hinge and outer edge of box covered in dark-gray leather. Lined in light-gray felt, with a wide green ribbon so book can be lifted out.

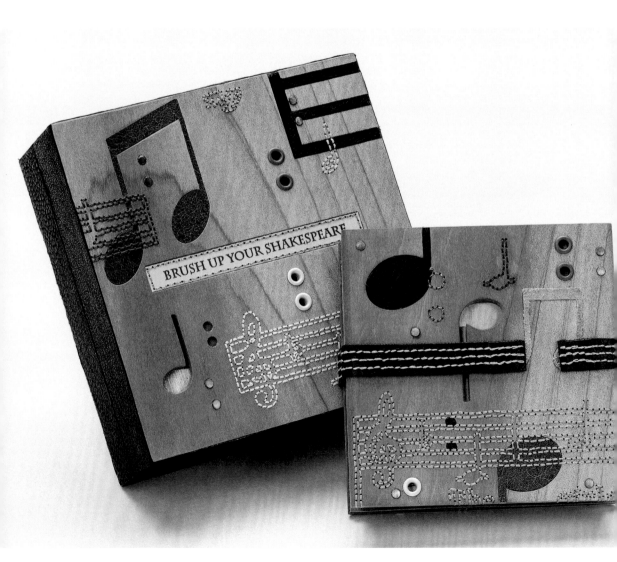

　　　　PART I: *Brush Up Your Shakespeare*

There are some wonderful illustrations throughout *Brush Up Your Shakespeare* that show two gangster characters dancing and singing the song. I decided to base my endpapers on the illustrations of those characters, printing multiple images of them to fill the space. It was the first miniature book that I had worked on, and I enjoyed it. It wasn't, however, the scale of the book that was the challenge; it was more that the book was made like a concertina. I decided to keep this format, rather than sewing the binding, which helped in my decision to use wooden boards for the binding.[8]

—Hannah Brown

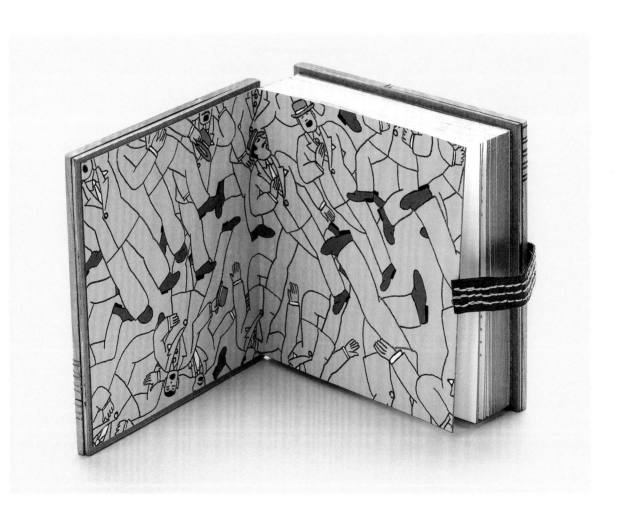

The making of *Brush Up Your Shakespeare*, bound by Hannah Brown, 2010.

1. Setting up the Computer Numerical Control (CNC) machine in preparation for cutting the pattern.

2. Test cutting one of the musical staves.

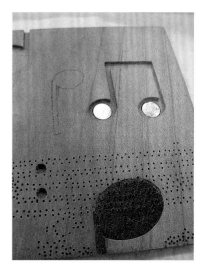

3. Inlaying magnets for the book-closing mechanism.

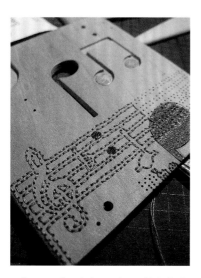

4. Sewing detail through small drilled holes in the wooden cover.

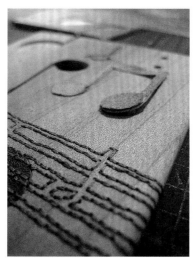

5. Concealing the magnets with a leather inlay.

6. Riveting a brass plate onto the inside of the wooden boards.

7. Preparing to lacquer the rivets.

8. Lacquering the rivets.

9. Constructing the box by gluing and clamping the lid and base in place.

10. Cutting grooves and gluing leather hinges in place on one side of the box.

11. Detail of the finished book with magnetic closure strap around the center.

12. Detail of the finished box covered in pared leather on all four sides.

LESTER CAPON

2012

Bound in full blue goatskin, with multicolored leather inlays and inlaid leather lines, tooled in gold.

Miniatures always present a different set of challenges. Because the book is so lightweight, it is sometimes tricky to make it open satisfactorily, especially if the paper is rather heavy . . . and there is always the danger of losing such a small item on the bench![9]

—Lester Capon

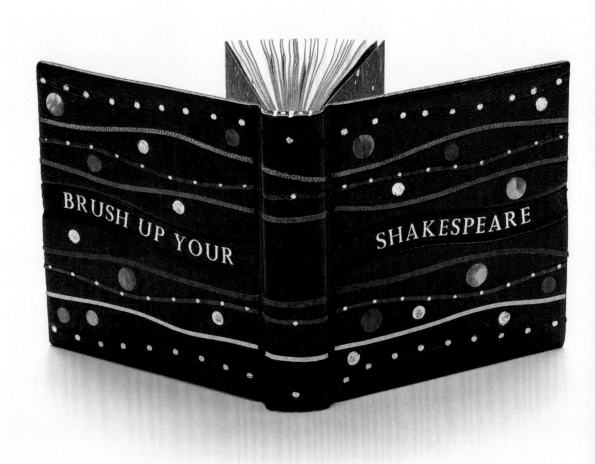

Bound in black leather, with vellum and paste-paper onlays.
All edges colored.

STEPHEN CONWAY

2012

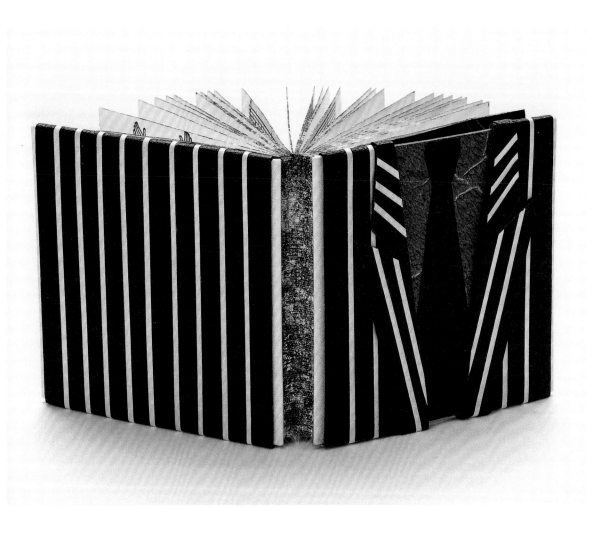

MARK COCKRAM

2010

Bound in goatskin, with hand-dyed design. Hand-printed doublures with worked gold leaf.

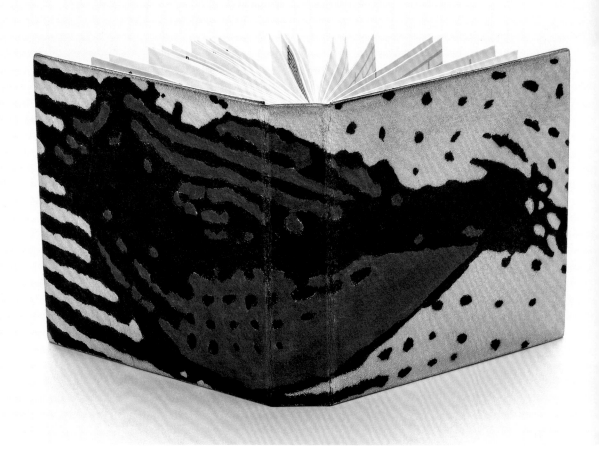

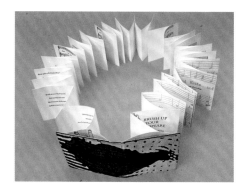

I wanted to explore the notion of the Elizabethan collar, or ruff, and the construction of the text block lent itself to that very well. The stylized pouting lips drawn on the covers hint at the reward of a secret/illicit kiss.

Every book I bind is a challenge, be it a miniature, a lectern tome, or an installation. I try to engage with the totality of the book; my work is only part of the alchemy of the book. The challenge is to keep fresh and to bind with purpose, not just to regurgitate a house style, as it were.[10]

—Mark Cockram

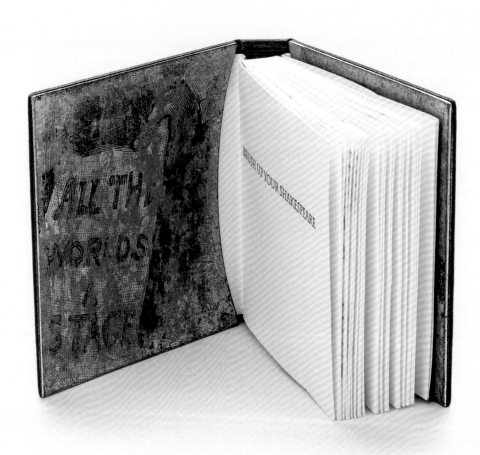

DEBORAH EVETTS

2010

Bound in full navy goatskin, with red and yellow onlays. Tooled in blind and gold.

I was looking for a symbol that brought to mind the theater, Shakespeare, players, etc. And the jester seemed to fulfill these requirements. The over-tooling of stave lines and musical notes came from the book.[11]

—Deborah Evetts

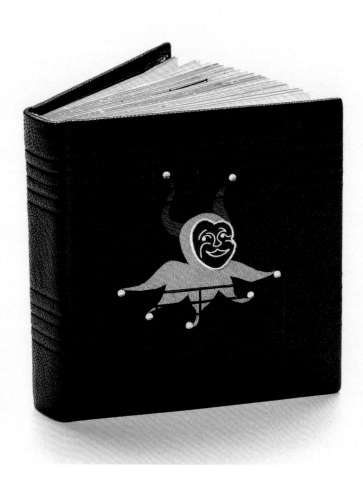

GABRIELLE FOX

2010

Bound in goatskin, with leather onlays and tooled in gold. Full leather doublures, with onlays and gold tooling. Goatskin flyleaves, with snakeskin onlays, palladium tooling, and partially lined with decorative paper. All edges colored.

PART I: *Brush Up Your Shakespeare*

The binding design was inspired by performances on stage of both *Kiss Me, Kate* and *The Taming of the Shrew*. The flyleaves are a visual pun on pinstriped suits. The quill-pen onlays on the doublures include the letter "B" for *Brush* (representing both the first letter in the title of the book and the Beginning) and "E" for the last letter of the last word in the title (*Shakespeare*) and for the End.

Miniatures always present challenges, but the major challenge in binding this book was that it was a concertina and not a sewn text. A structure had to be developed that let the text open well but not flop out.[12]

—Gabrielle Fox

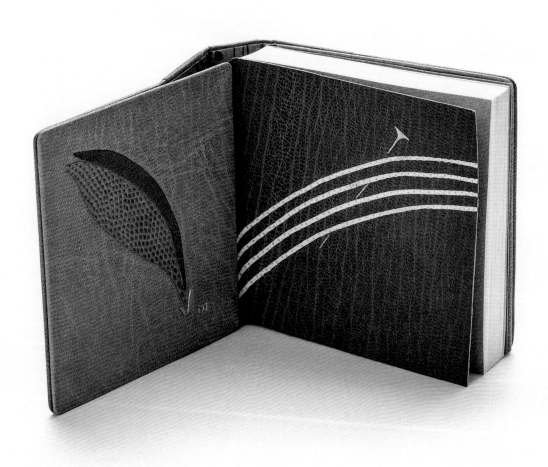

ANNETTE FRIEDRICH

2010

Bound in full burgundy goatskin, with diagonal purple onlays and tooling of "1-2-3" on front cover. Triptych foldout structure, with added half panels at head and tail. Title in bold yellow onlay letters revealed when panels are unfolded. Final panel, tooled with radiating lines in three shades of silver and iridescent foil, attached to concertina text block.

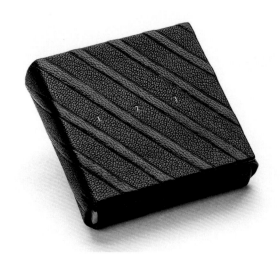

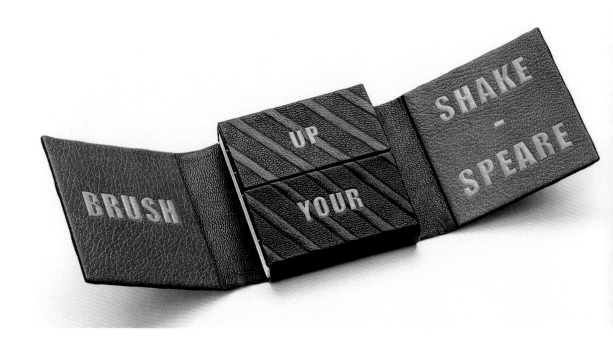

I imagined that the whole piece should work like a
small performance in itself: sophisticated curtains,
the countdown with snapping figures: a one, a two,
a one two three!

And then the curtains lift and the stage lights come up:
Brush – Up – Your – Shakespeare!!!

A drum roll and then:
Spotlights on!!!!!
Dazzling light!!!!
And offfff we go!!!!!
Sing!!!![13]

—Annette Friedrich

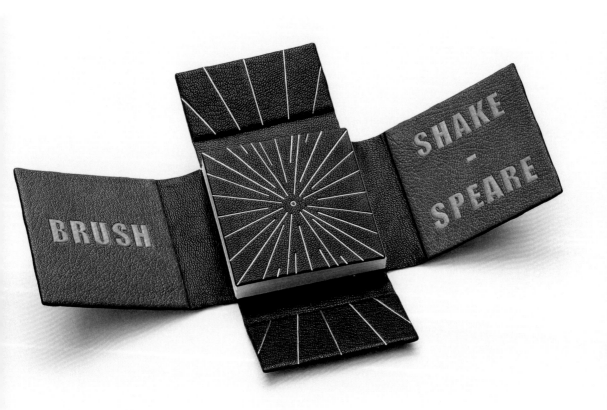

SAYAKA FUKUDA

2012

Book divided into three parts, representing the number of "acts" in "Brush Up Your Shakespeare." Each part covered with a hinged wood door, laid into wood tray covered in flower-patterned Japanese silk.

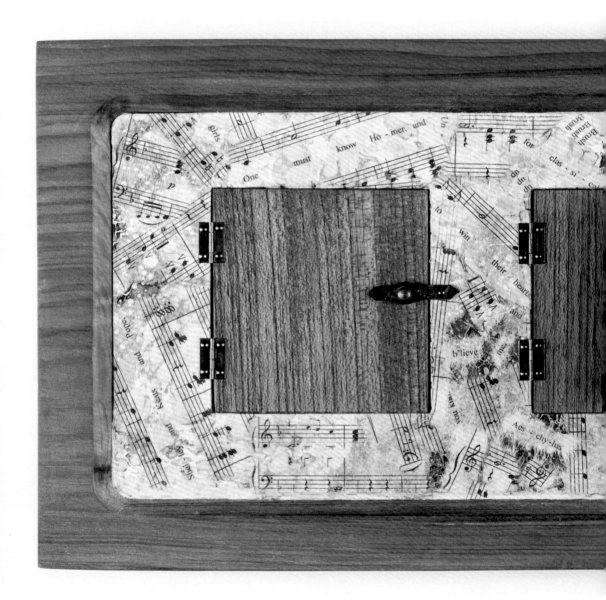

PART I: *Brush Up Your Shakespeare*

I attempted to convey the essence of comedy and the theatrical setting of the original musical *Kiss Me, Kate* through the opening mechanism of each part of the book. They were designed to suggest the surprise of a cuckoo clock, with the bird "popping out" action—unfortunately, with no clock mechanism attached. (That would have been even better; maybe for another book!) I hope opening each door brings the reader a moment of excitement.[14]

—Sayaka Fukuda

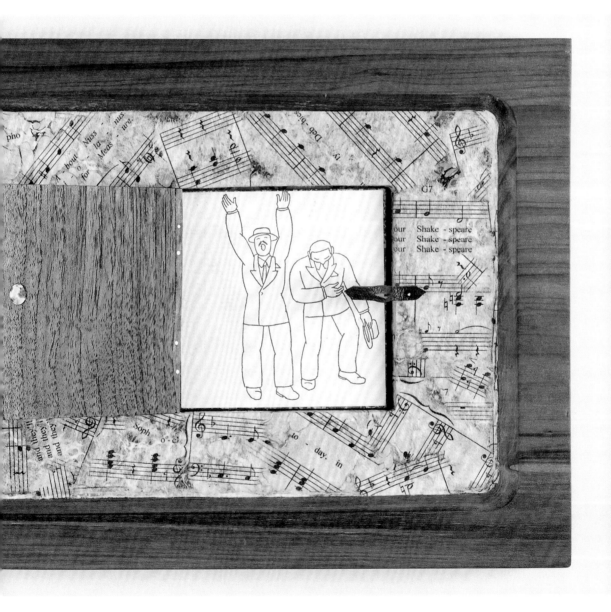

ERI FUNAZAKI

2013

Bound in transparent vellum over full calfskin; figures underneath printed offset on Zerkall paper. Vellum extended to create pockets used to attach text block to cover. Box covered in full calfskin, with onlay of two figures.

 PART I: *Brush Up Your Shakespeare*

As the lyrics of the song come from a dancing scene in a musical play, the book structure has a few added dimensions to reflect the different steps of the dance. The figures on the cover and the box form a pair of the dancing gangsters even when seen from different angles.

Surprisingly to me, a smaller text block doesn't shorten the time needed for designing and binding very much. It is of course much more fiddly than binding a conventionally-sized book. I always find it tricky to choose material for the boards for miniature books; it has to be thin yet heavy enough to close. So I tend to laminate the material in order to lend it substantial weight.[15]

—Eri Funazaki

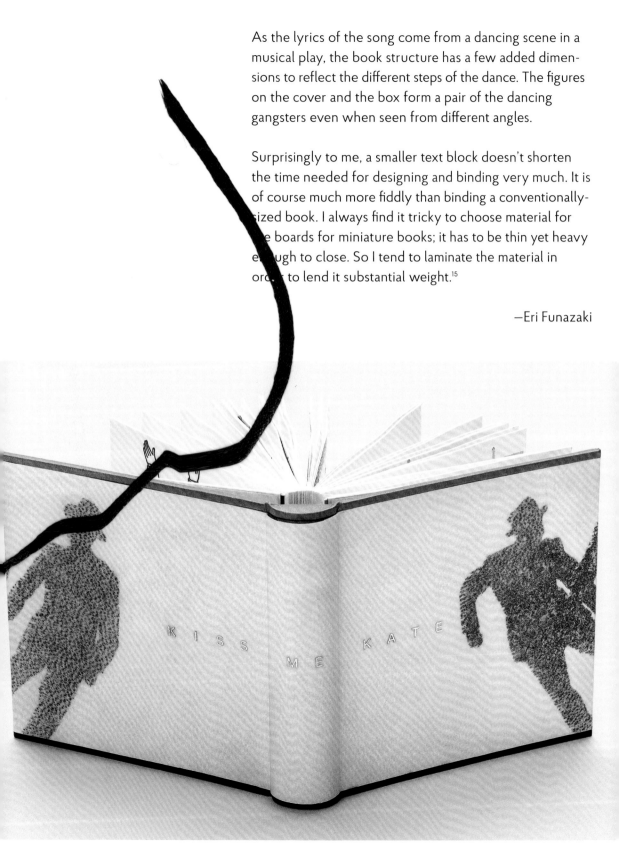

JENNI GREY

2010

Bound in royal blue velour with hand embroidery in silver and green threads, and blue paua-shell cabochons in silver settings with glass beads.

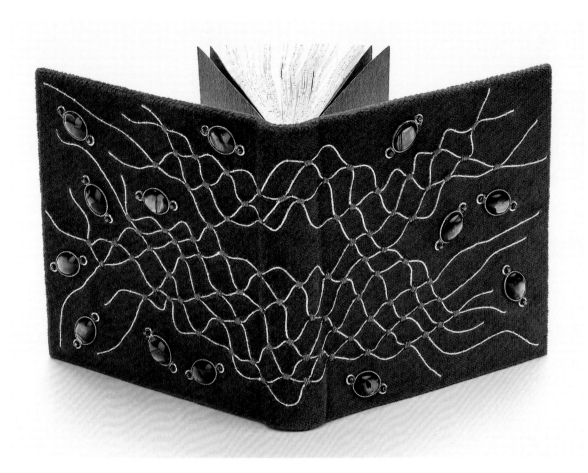

The initial ideas stemmed from using musical notes, and the design evolved into using graphic representations of sound waves. These were manipulated and linked together to form a sound-wave net. The paua-shell cabochons occupy spaces around it, visually emphasizing the movement of the form without becoming ensnared by the net.[16]

—Jenni Grey

Bound in tan Harmatan Nigerian goatskin, with multi-colored goatskin onlays outlined by thin gray onlays. Edges painted in acrylics. Designs on the front and covers joined across the spine with a curved brown onlay uniting the two panels.

SIMEON JONES
2010

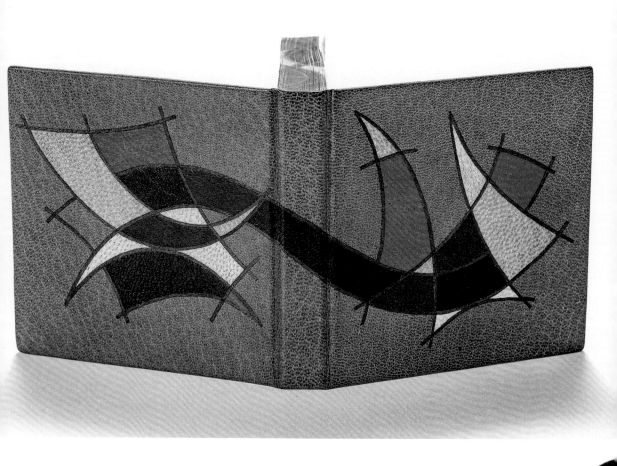

The edges of the text block are painted in brown, red, yellow, and orange in a curvilinear abstract design. This was the first step in the design process and was created spontaneously in response to the rhythmic, musical dance of the text. The outcome was so pleasing that it became the basis for the cover design. I strive to make each binding a *Gesamtkunstwerk*, a total work of art, and wanted the design to be unified across the front and back covers.[17]

—Simeon Jones

DEREK HOOD

2010

Bound in dark-brown goatskin, with multiple colored onlays within white linear recessed outline. Leather-jointed endpapers, with decorated Japanese-paper doublures that emulate musical staves in the text. The five lines of the stave are carried over onto the front board. Title, dots, and book edges gilded in 24-carat gold leaf. Covered in leather chemise and enclosed in leather slipcase.

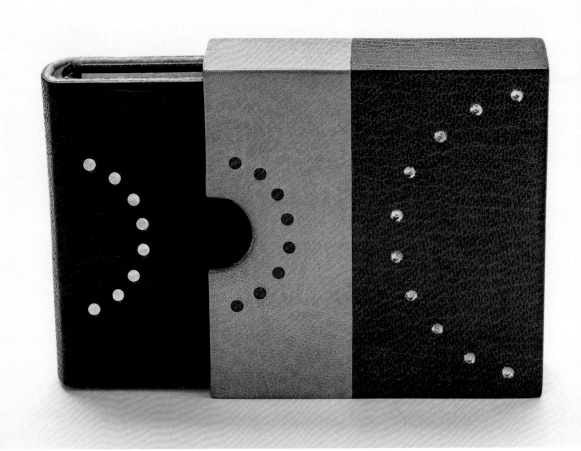

PART I: *Brush Up Your Shakespeare*

The flowing form cutting through the angular framework on the front alludes to both female characters in *Kiss Me, Kate*. The red circle represents the roses sent by Fred to Lois but mistakenly delivered to Lilli, thus leading to the ensuing tension onstage. The staccato dots of the spat shoes and the angular zoot suits worn by the two gangsters are also alluded to within the design.[18]

—Derek Hood

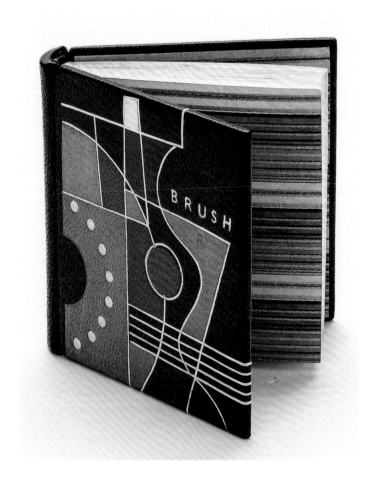

ANGELA JAMES

2011

Bound in blue goatskin, with red, white, and printed calfskin onlays on front and back covers. Lettered in black across both boards. Pasted-down endpapers over red goatskin, with paper collage of Shakespearean characters at front and portrait of Shakespeare at back.

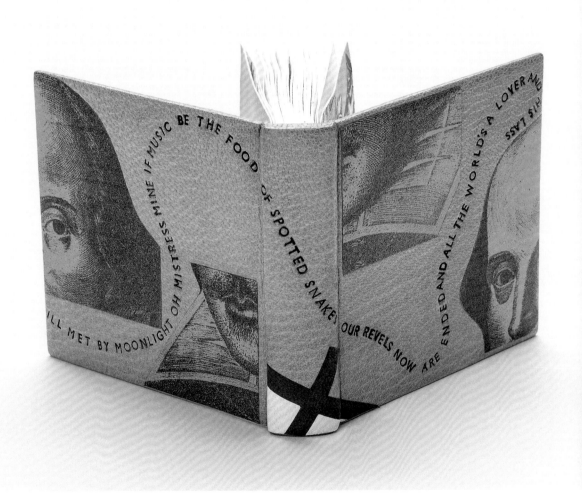

I love working on miniature books. The scale doesn't really pose any problems—except perhaps that my eyesight is not as acute as it used to be—but I do enjoy working in such a neat little space that requires quite different thinking from a normal-size book. I can experiment, too, without the fear of wasting materials.[19]

—Angela James

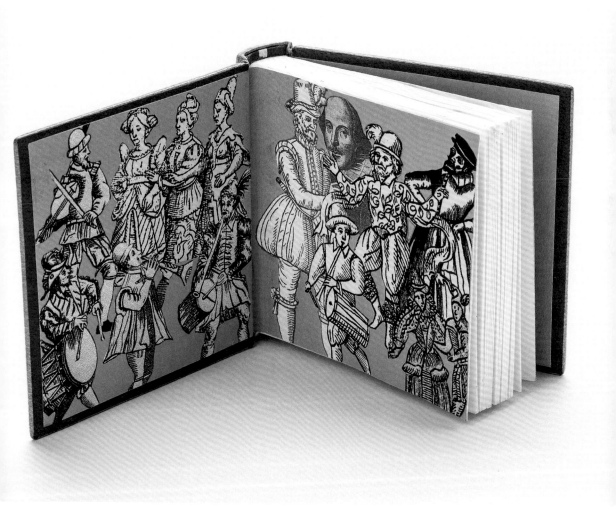

GEORGE KIRKPATRICK

2015

Bound in red goatskin, with polypropylene covers printed in gold with silver dancing figures mounted underneath. Edges in red, sprinkled with gold. Title tooled in gold on spine.

I like my bindings to relate to the content, so I decided to do something with the music and the dancers illustrated in the book. I do not know the musical, but I just liked the idea of the two men dancing, and so this came from it. I did not think at first of making a three-dimensional work, but then I fancied the idea of using something transparent. I started to play with the possibility of printing gold onto the transparent material, and I liked it. It was the whole idea of showing how you could dance and make music at the same time. I made the figures from very thin, pure silver. It was important for me that it was pure silver, not sterling (an alloy that contains other metals). Pure silver is very soft to work with, but it remains shiny, while sterling can go black in time. Then I played with how to create a space between two layers of the polypropylene where I could put the figures. I drilled little pins to hold the binding together.[20]

—George Kirkpatrick

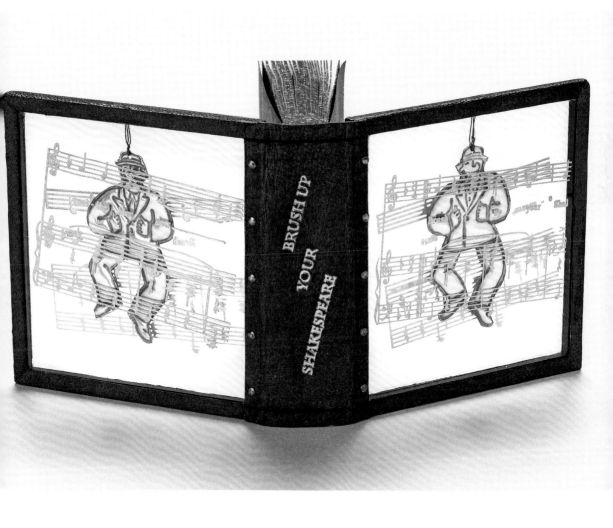

MIDORI KUNIKATA-COCKRAM

2010

Bound in dark-brown oasis goatskin for frame and terracotta Nigerian goatskin for spine, with hand-drawn gouache illustrations. Enclosure [opposite] made of Zerkall paper and Irish linen.

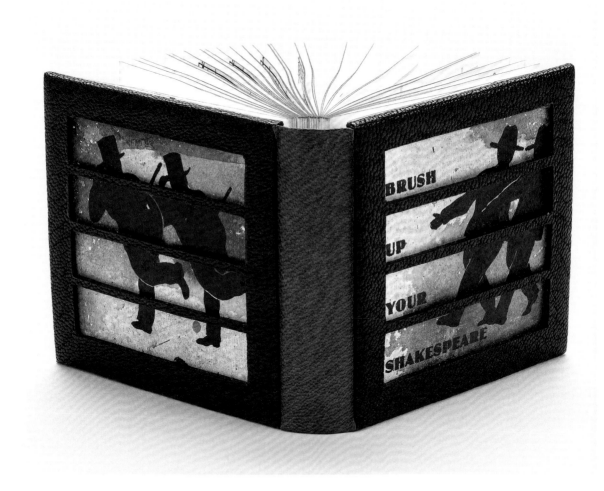

The book was conceived as both a codex and a concertina, with a sliding spine. The image on the codex book design is based on the stage performance of *Kiss Me, Kate*. When the spine is slid out from the leather frame cover, the musical score of "Brush Up Your Shakespeare" appears, and it becomes a concertina book. The enclosure is in the form of a boater, evoking the hats worn by a few of the characters in the musical.

I try to make miniature books in the same way I make other books. The only difference is that the tools and materials I use are finer. In my mind's eye, I work with the image of the miniature book through the lens of a camera, enlarged, as it were. So when images of my miniature bindings are placed side by side with images of full-size books, there is no apparent difference.[21]

—Midori Kunikata-Cockram

MONIQUE LALLIER
2010

Bound in full goatskin, with onlays of skins and rounds of sanded leather. Box covered in goatskin, with leather onlays.

The design is based on the two men dancing and "playing" with their hats in the song: the legs on the cover and the box represent the dancers, and the small circles, their hats.[22]

—Monique Lallier

YUKO MATSUNO
2011

Bound in yellow goatskin, with diamond-shaped windows on front and back boards; green goatskin inlays on front board and spine; and green Swarovski crystals. Edges hand-colored. Title tooled in gold on goatskin discs (with "Brush Up Your" on the yellow side and "Shakespeare" on the reversed green side). Pasted-down endpapers hand-printed with hand-carved rubber blocks. Housed in a drop-back box covered in green cloth, with yellow and green goatskin inlays and title tooled in gold.

PART I: *Brush Up Your Shakespeare*

The design, colors, and pattern were inspired by the beautiful costumes and sets in the musical *Kiss Me, Kate*. I have tried to recreate the delightful atmosphere of the musical on both my binding and the box. The diamond motif, in particular, was inspired by one of the costumes Kate would wear in the staging of *The Taming of the Shrew* that is part of the musical, and by the lattice patterns of the late Tudor period, when Shakespeare's play was written. The scenes in *Kiss Me, Kate* shift frequently between the stage and backstage. I tried to reflect this amusing situation by putting reversible discs in the windows on the front and back boards.[23]

—Yuko Matsuno

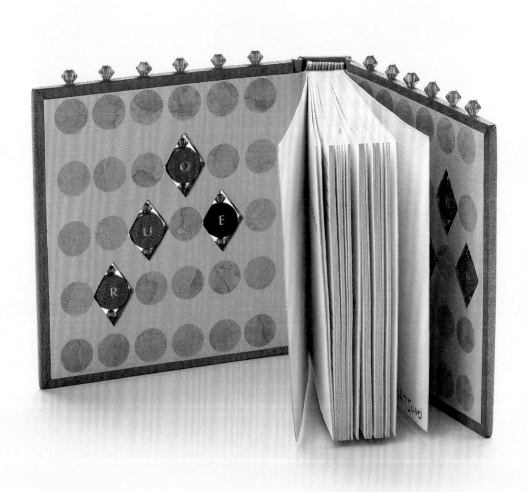

YEHUDA MIKLAF

2010

Text block sewn on linen tapes covered with red and yellow Harmatan goatskin and inlaid into boards covered in purple and green Harmatan goatskin, with feathered onlays in various colors. Marbled endpapers. Linen-covered box.

PART I: *Brush Up Your Shakespeare*

My first inclination was to put William Shakespeare on the cover of the book—but then I thought that everyone would do that. As a concession, I put him on the box. Because the lyrics of the song are so bright and happy, I tried to convey the same feeling with color to make a light, bright, and cheerful binding.[24]

—Yehuda Miklaf

TINI MIURA

2015

Bound in full red goatskin, with multicolored onlays and gold tooling. Six cutout figures, each outlined in leather strips. Leather doublures with gold and silver dots on multicolored sheepskin. Pale-yellow leather headband; pink suede flyleaves with silver dots. Wraparound covered with purple goatskin, lined with Japanese crinkle-paper leather; magnetic closure.

I felt that because so much thought had been put into the accordion construction by the designer [Leonard Seastone], I needed to respect that. So I did not attach the text block to the spine, and that meant I could display the text freely. Next, I wanted to take up the fun illustrations of the two performers, continuing the "picture" story in the book on three folds of the binding on each side. The book is tiny and practically weightless, so displaying it open would be a problem. I needed a "stage" for the display. I made one that allows the book to stand fully open. And, since it could not remain on display, I needed to make a box and wraparound for the book to protect it.[25]

—Tini Miura

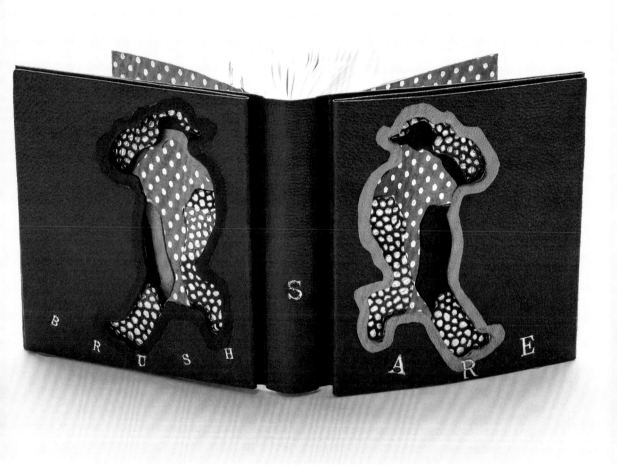

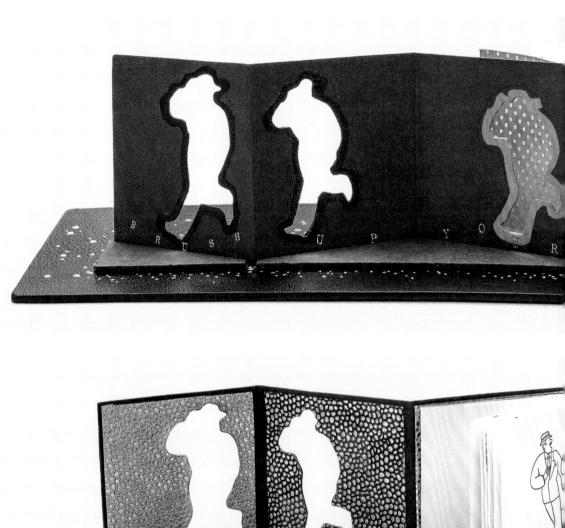

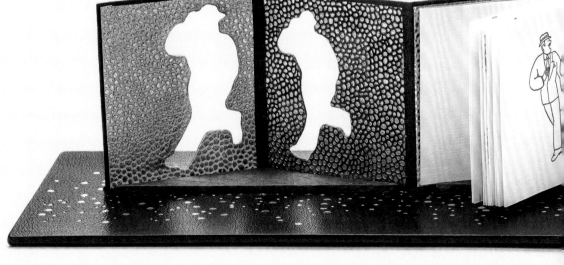

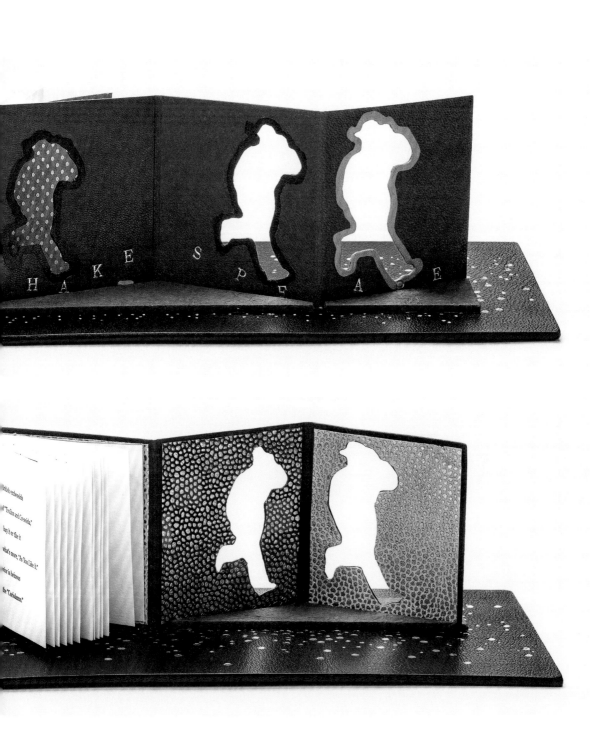

DAVID PENTON
2010

Box binding, with black and red goatskin. Brown goatskin, calfskin, and snakeskin onlays.

The end leaf of the text is glued to the inner tray, which is covered with red goatskin and set into an outer tray covered with black goatskin. The front leaf is glued to the inside of the lid that is covered in black goatskin. Affixed to the lid is a cover with a slight dome that is covered in black goatskin with onlays in shades of brown goatskin, calfskin, and snakeskin, with the central onlay made of the same leather as the inner tray. These reflect the style of hat worn by the gangsters in the book's illustrations.[26]

—David Penton

ELEANORE RAMSEY

2015

Bound in full white chagrin goatskin, with dark-blue and orange goatskin mosaics. Title and author tooled in gold on spine, with musical score and notes in yellow and blue mosaics tooled in blind. Top edged in gold, with blue, orange, and yellow silk headbands, and yellow seude flyleaves. Clam-style box with leather spine and gold-tooled title; boards covered with a paste paper chosen to suggest suit-lining material.

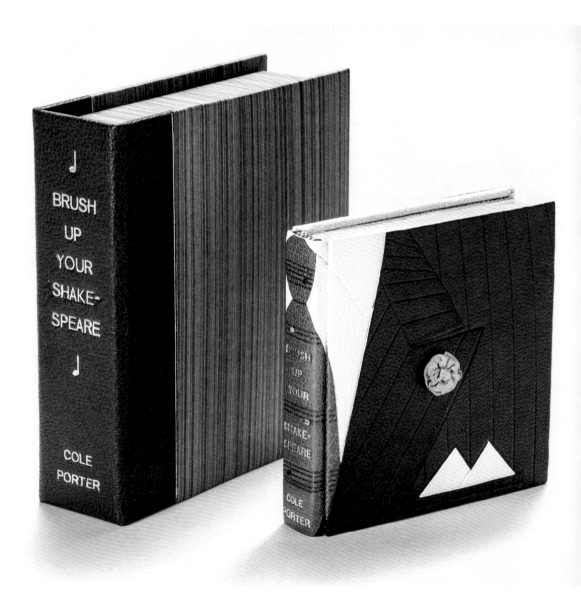

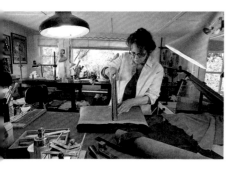

The covers reflect the book's illustrations, with a 1940s Cole Porter-style man's dark-blue suit jacket. The front cover includes a yellow leather three-dimensional boutonniere in the lapel buttonhole and a white handkerchief in the breast pocket.[27]

—Eleanore Ramsey

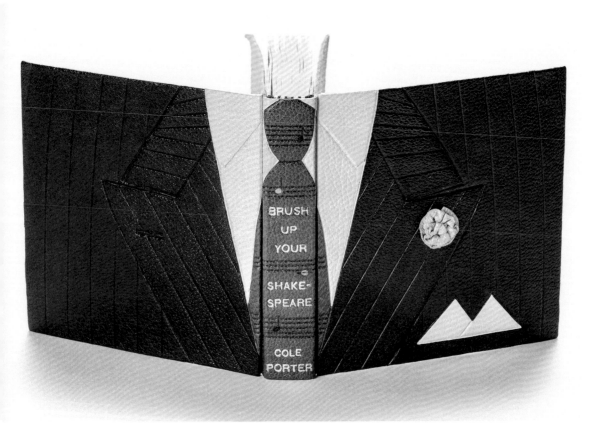

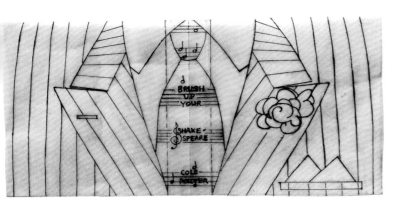

SOL RÉBORA

2010

Bound in full white goatskin, with gold lines and pierced with small holes that reveal a glimpse of the black paper underneath.

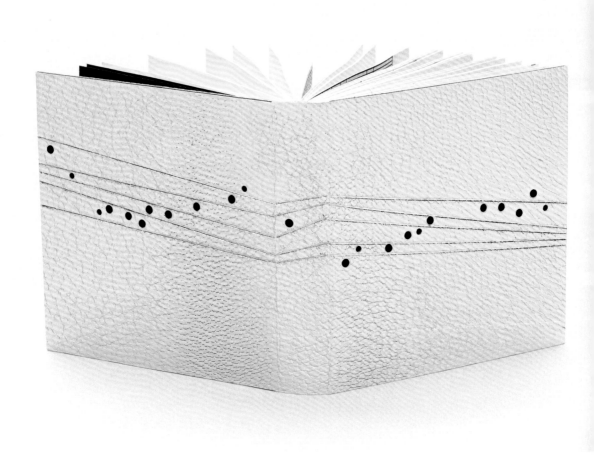

PART I: *Brush Up Your Shakespeare*

Neale Albert let me be completely free to work with his book, to find the design I felt was perfect. In this case, the design evokes a musical score.[28]

—Sol Rébora

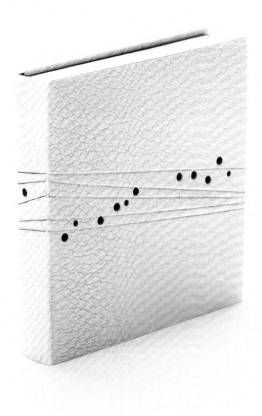

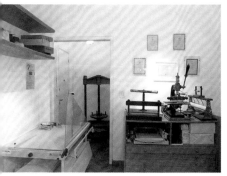

SEAN RICHARDS
2015

Bound in full black goatskin, with title tooled in gold. Sculptural enclosure constructed from laser-cut layers of thin, acid-free board and covered in multiple onlays of red goatskin in various shades.

The structure of the book was altered from the accordion-like assemblage to a more traditional one for my purpose. The text block was disassembled and the leaves hinged to form sections that were more easily sewn onto traditional supports. The skull itself was formed from a pattern that was translated to miniature scale via a three-dimensional scanner used to take a detailed scan of an actual skull. The idea was an attempt to add an absurd juxtaposition to the whimsical text of the Porter song ("If you can't be a ham and do Hamlet/They will not give a damn or a damlet") by encasing the volume in a kind of vanitas.[29]

—Sean Richards

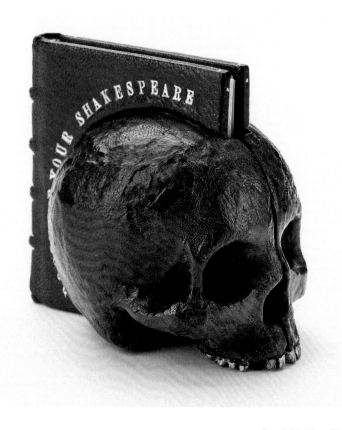

PART I: *Brush Up Your Shakespeare*

Bound in full red goatskin, with undyed goatskin onlays.
Undyed goatskin doublures with red onlays.

HAEIN SONG

2010

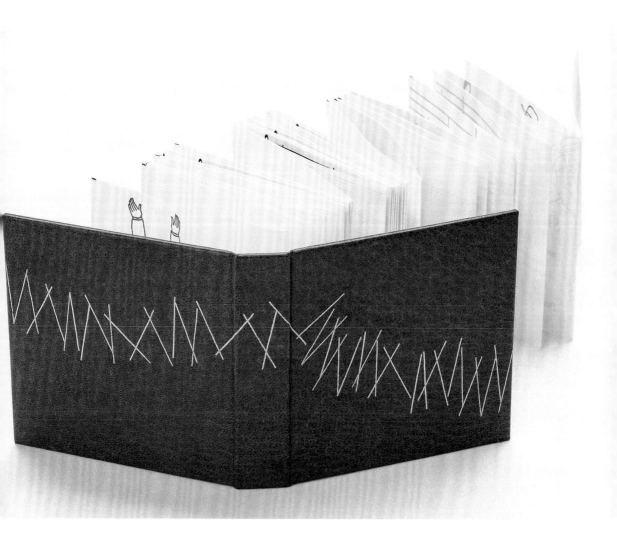

The design comes from the structural and musical elements
of the book.[30]

—Haein Song

DAVID SELLARS

2011

Bound in reversed pigskin, with spine of variegated Nigerian goatskin. Goatskin, calfskin, vellum, and frogskin onlays. Tooling in black, with colored edges. Doublures of Nigerian goatskin, with handmade Korean endpapers. Box covered in linen and decorated paper with leather label.

I wanted to celebrate Cole Porter and his work over the years as well as the particular song. I always think of Art Deco when I reflect on those decades, the buildings, especially theater lobbies and elaborate objects—including bindings. I wanted this binding to echo that look.

For the sides of the book I have chosen a pig suede to give a textured feel and to contrast with the Nigerian goatskin on the spine; the onlays are a mixture of types of goat, calf, vellum, and frog. The doublures of Nigerian goat reflect the surface of the leathers while the free endpapers, made from Korean handmade paper, echo the rougher texture of the suede. The colors of the large

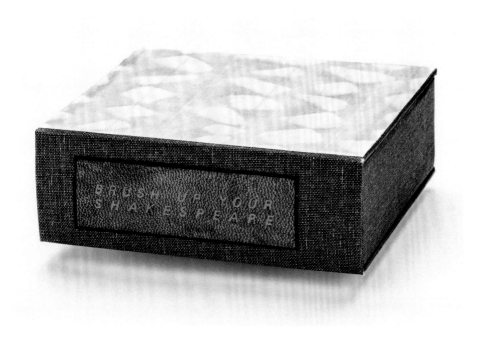

planes are kept subdued in sympathy with the printing of the text block. The inlays of black staves and "notes"—the "visual music"—is, of course, complete fantasy. I hope that the whole dances and is gay and magical, which is how I feel about the Broadway musical.

While miniatures pose particular structural problems for the binder to solve, they are always huge fun. In this instance, it allowed me a break from the large solemn texts with which I am usually engaged.[31]

—David Sellars

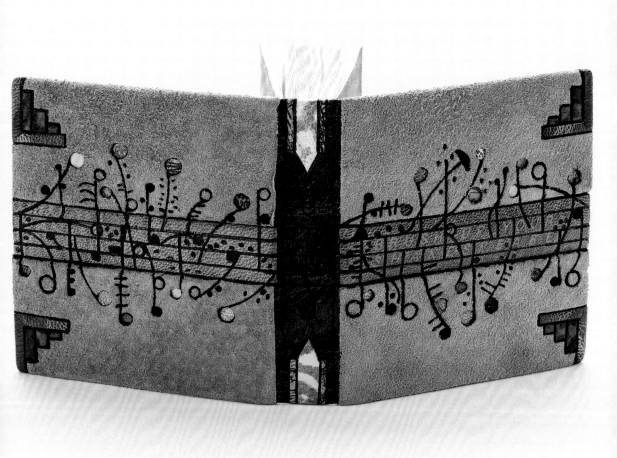

PHILIP SMITH
2011

Shaped boards covered in blue and red goatskin, with title and circular designs blocked in blind.

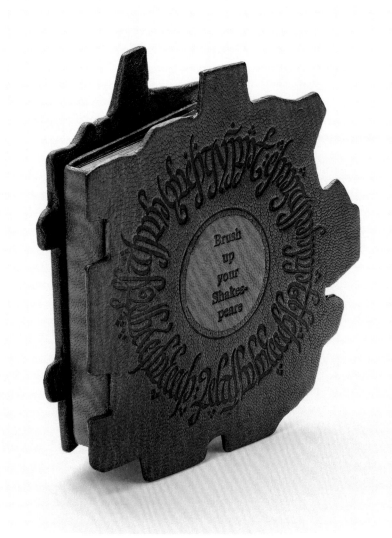

The designs should speak for themselves. The designs appear after reading the books, and just seeing what happens. I like to improvise.[32]

—Philip Smith

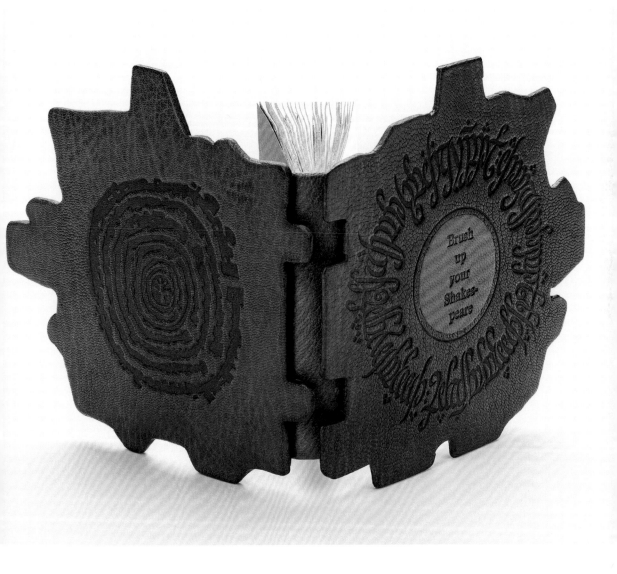

JAN SOBOTA

2011

Bound in black goatskin. Front board contains an aluminum plate with a brass mechanism that allows the figures to move when the small handle on the side is pulled. Title tooled with metallic holographic silver foil. Edges covered in brown goatskin, tooled in black foil with names of the author and illustrator.

Also inside box: two hats, made of black suede leather, with "Neale Albert" gold-stamped inside one brim and binder's name inside the other.

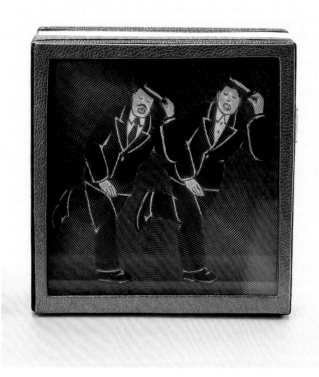

Bound in dark-blue goatskin. Decorated with colored onlays, raised relief, and gold tooling.

JARMILA JELENA SOBOTA

2009

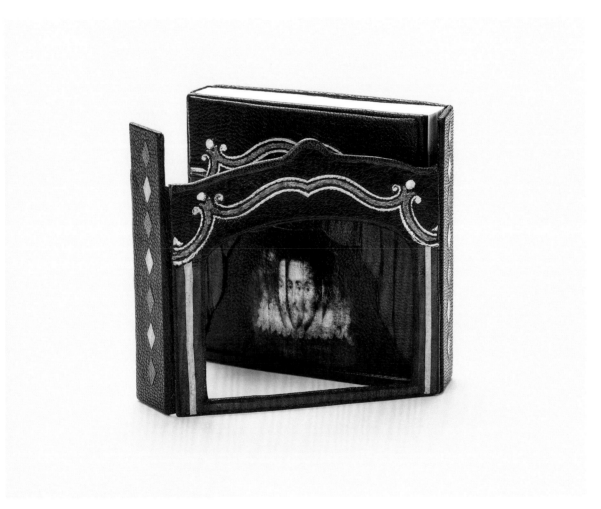

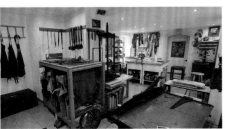

The design of the binding symbolizes a theater stage.[33]

—Jarmila Jelena Sobota

ALAIN TARAL

2010

Bound in veneers of various woods (including amboyna, bird's-eye maple, padauk, plane, purpleheart, and walnut) using fusion marquetry.[34] Title hot-stamped on spine with foil.

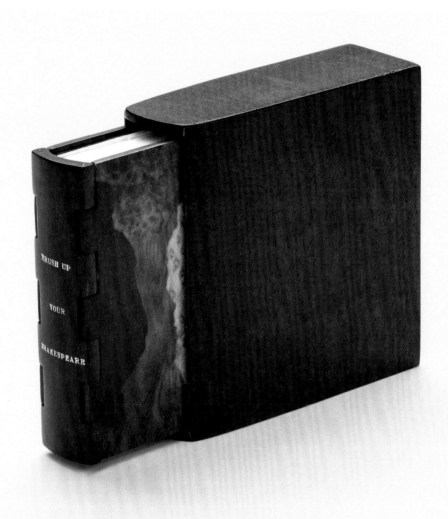

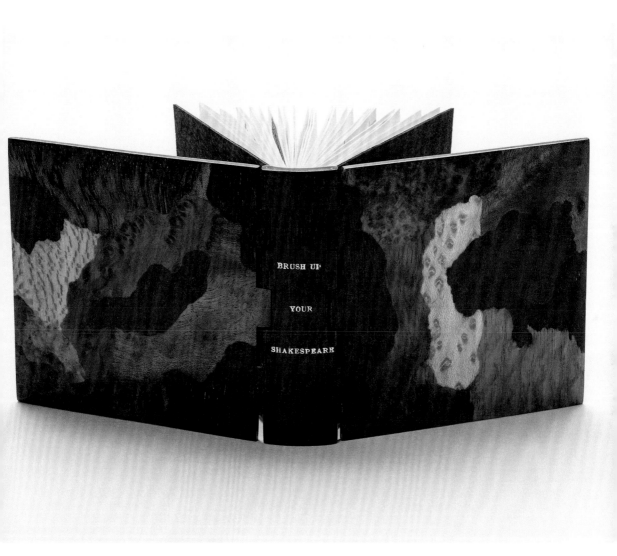

JULIAN THOMAS

2011

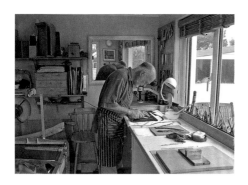

Bound in sheepskin, with printed portrait of Shakespeare colored with leather-dye washes. Spine and board edges covered with printed and dyed calfskin representing the character Kate in a red dress. Boards with gilded, embossed, and dyed leather onlays, with edges painted with pale-blue acrylic. Blue, purple, and pink silk headbands. Green goatskin doublures complementing color of Shakespeare's tunic on cover. Box lined with red velvet and covered with a pinstripe wool material.

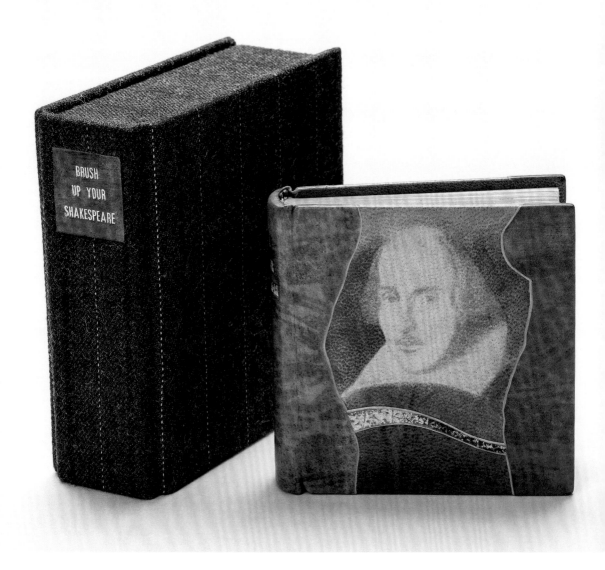

Bound in French polished and lacquered veneers of American walnut and dyed chestnut. Spine covered in Harmatan goatskin.

DANIEL WRAY

2010

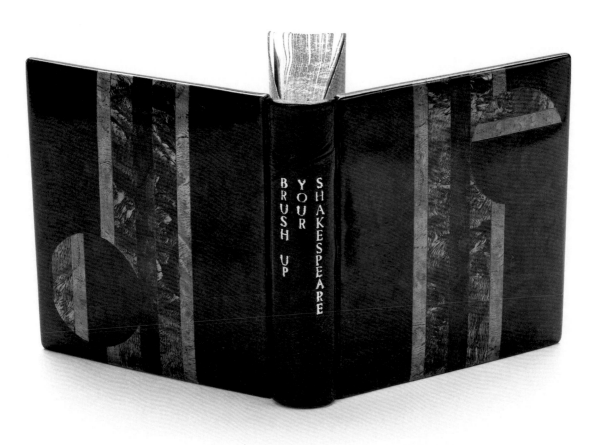

The design was simply what I happened to draw that day while looking through the text. There's nothing intellectual involved. It is simply a response.[35]

—Daniel Wray

ANN TOUT

2014

Bound in goatskin, with onlays, on a blind-tooled background. Graphite edges with fore-edge painting. Vellum slipcase with cutout arches; transparent-vellum outer slipcase with pen-and-ink drawings, with a white watercolor wash.

Brush Up Your Shakespeare is a lively little book that required a binding to convey a sense of expressive movement. Blind tooling was decided on, since the lines can be varied in tone and repeated [to] give vitality to the movement desired. When the blind tooling was almost completed, I added dyed onlays to the figures. I felt a stage atmosphere was needed, and used graphite for the edges to create a fore-edge painting of a dancer—to bestow a light and shadowy backstage quality to the binding.

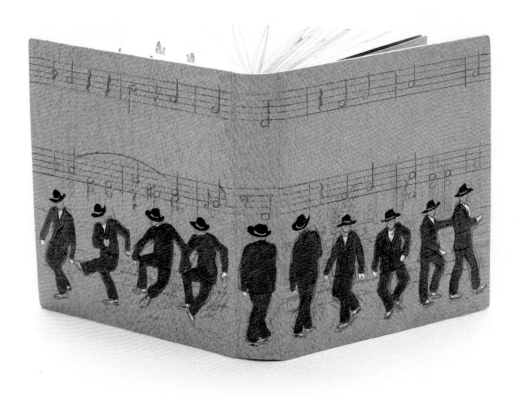

PART I: *Brush Up Your Shakespeare*

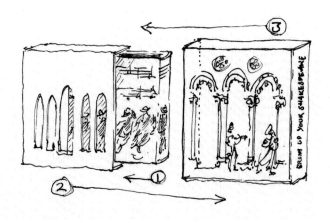

The slipcase forms part of the stage scenery that encompasses the figures depicted on the binding. The inner vellum case is lined with handmade paper, while the outer one is formed from transparent vellum and decorated with pen-and-wash drawings. Using both the round and pointed arch gives the set more depth and perspective.[36]

—Ann Tout

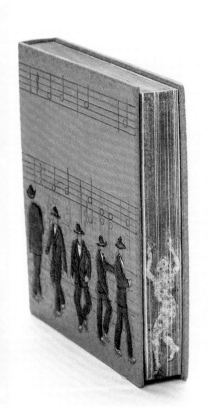

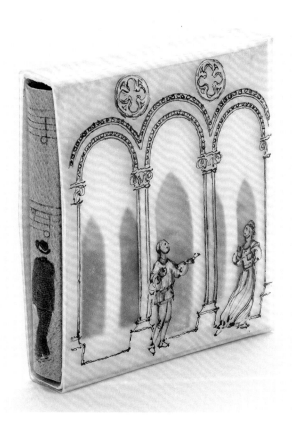

MICHAEL WILCOX

2010

Box binding, with red goatskin covers. Leather onlays and gold tooling, with gilt edges.

It is difficult to know exactly how to describe this kind of binding. Of the descriptive terms I have come across, "box binding" . . . seems the best, although the concertina-like text is not bound but simply attached to the box at its beginning and end. Really, the object is more a box than a binding, but it does the job of a binding.

I wanted to preserve the free and lively effect created by the use of the concertina-like arrangement. The box binding allows the leaves to be turned and viewed in the usual way. But, by drawing out and spreading the concertina, it is also possible to display large amounts of the text simultaneously, which gives a greater sense of connection and motion to the musical notes and words.

My design is not intended to illustrate the song as performed onstage. (I've never seen *Kiss Me, Kate*.) The cartoon-style characters represent what I think might result when men offstage apply the advice that the song gives: amusement, indifference, or mild astonishment. In contrast, the ornamental part of the design refers to

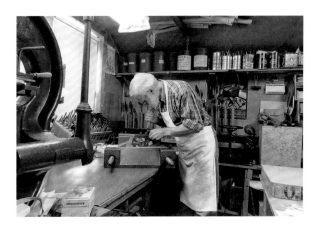

the more pastoral mood associated with Shakespeare's time. I cut the "tilting-spear" tool, seen with the Bard's coat of arms, especially for this work. The titling down the spine was divided in a way that I thought might suggest the kind of playfulness with words that [Cole] Porter so delighted in.

As with all miniature bindings, this one demanded a lot more work than the end product might suggest. However, *Brush Up Your Shakespeare* was my last miniature, and now that I have stopped taking commissions, it is unlikely that I'll be binding any more tiny books in the future.[37]

—Michael Wilcox

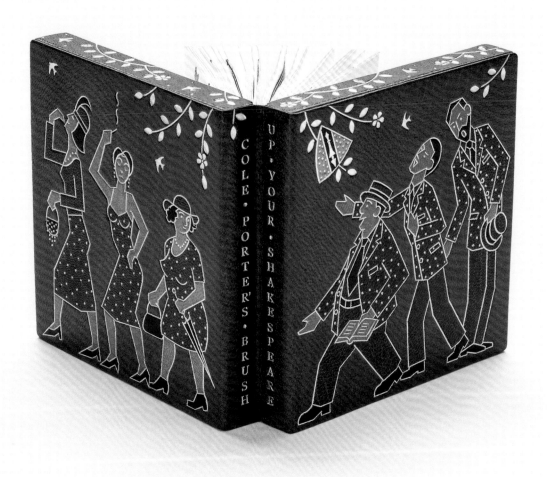

ROBERT WU

2015

Bound in full blue French goatskin, with pink leather onlays and tooling in blind, gold, and colored foil. Gilt and tooled top edge. Hand-sewn red, blue, and yellow silk headbands. Doublures made of binder's own handmade marbled paper.

I wanted to play with the musical and text elements from the book illustrations and reinterpret them in my own dynamic composition.[38]

—Robert Wu

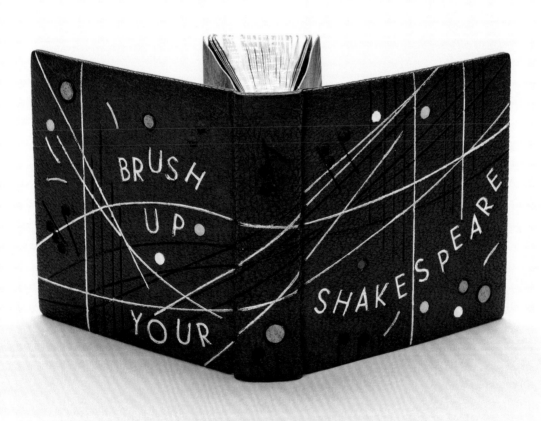

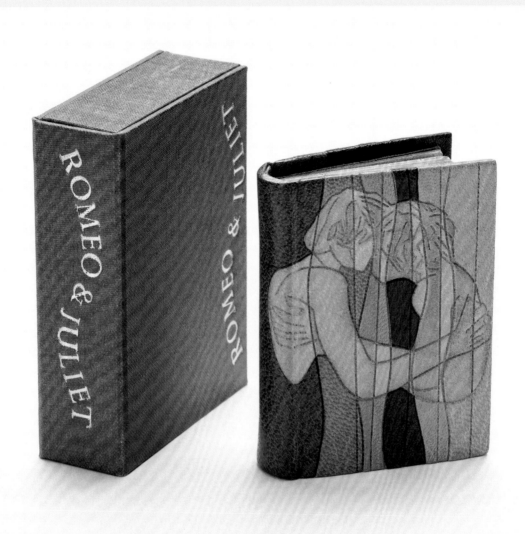

Romeo and Juliet, bound by Paul Delrue, 2005.

KNICKERBOCKER'S SHAKESPEARE

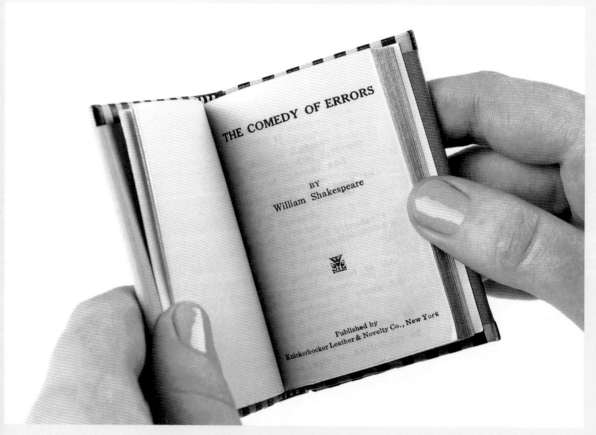

The Comedy of Errors, bound by Angela James, 2007.

Shakespeare's Works (New York: Knickerbocker Leather and Novelty Company, ca. 1910)

Neale Albert asked a number of designer bookbinders to rebind the volumes of the Knickerbocker set of Shakespeare. He allowed them to select the play or poem and, as usual, neither offered design guidance nor imposed any constraints.

SUSAN ALLIX

VENUS AND ADONIS
2006

Bound in full undyed goatskin, with white calfskin onlays. Inlays of single- and double-sided pencil and watercolor portraits under transparent vellum. Lines in red dye and black ink; small onlays in violet, red, and green leather and paper; tints in watercolor, with red ink sprinkling. Edges colored in red acrylic. Blue silk headband. Dark-red goatskin doublures. Endpapers mottled red and purple with watercolor on Japanese paper. Includes dark-red leather display "shoe." Title printed on green leather. Dark-red cloth and leather box, lined with emerald-green felt.

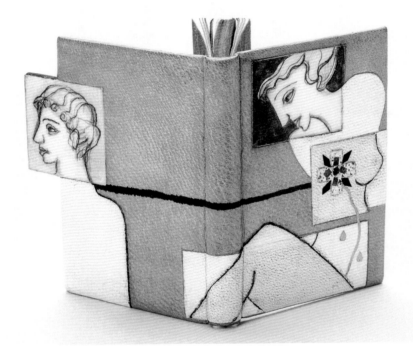

And in his blood that on the ground lay spill'd,
A purple flower sprung up, checker'd with white
Resembling well his pale cheeks and the blood
Which in round drops upon their whiteness stood . . .

And says within her bosom it shall dwell,
Since he himself is reft from her by death.
She crops the stalk, and in the breach appears
Green-dropping sap, which she compares to tears.

—*Venus and Adonis* (lines 1167–70 and 1173–76)

I like the feeling that, as *Venus and Adonis* is very connected to Shakespeare's patron [Henry Wriothesley, Earl of Southhampton], another patron [Neale Albert] has commissioned a binding of it—the continuation of a theme. The poem contains very many vivid Shakespearean images and moments. . . . The verses [on opposite page] refer to special points in the binding.

When a book is a miniature, its size seems to magnify the feeling of its being an "object." The double-sided portrait aims to give some three-dimensionality to the shape, with the red "shoe" serving as an aid to viewing the closed book.[39]

—Susan Allix

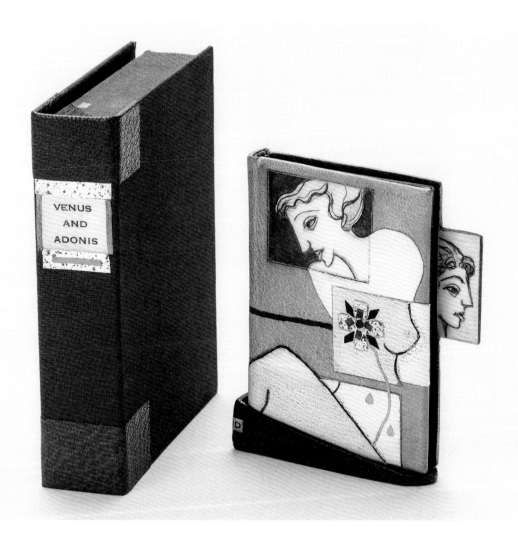

GLENN BARTLEY

HAMLET

2005

Bound in full brown goatskin, with recessed dark-blue and light-blue goatskin onlays. Blind and gold tooling on covers and spine. Blue suede and blue-gray handmade endpapers. Gray goatskin doublures. Silk headbands.

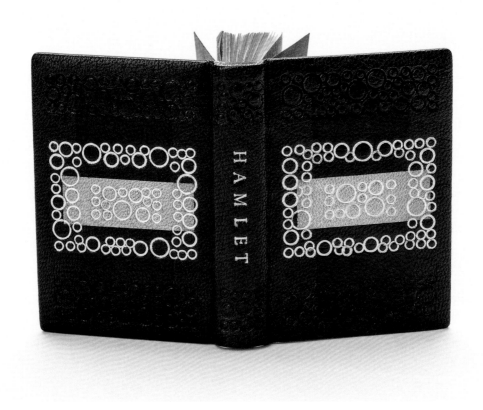

Bound in green goatskin, with gold and red tooling. Miniature portrait medallions, painted by John Hodgson, on front and back covers in imitation of a Cosway-style binding.[40]

SANTIAGO BRUGALLA
JULIUS CAESAR
2004

JO BIRD

KING HENRY VIII
2006

Bound in reversed goatskin backed onto Japanese paper. Cover text hand printed in Goudy bold/italic and Centaur fonts on an Adana press.

I wanted to use the lead type as a direct reference to the history of the printed word, and as a reference to the period in which the play was written. I wanted the overall look of the book to be modern and graphic. The quotes taken from the play display the power and beauty of the printed and spoken word.[41]

—Jo Bird

LESTER CAPON

KING HENRY V
2006

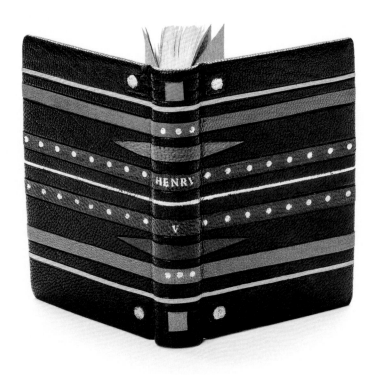

PART II: Knickerbocker's Shakespeare

Bound in full dark-green goatskin, with colored calfskin onlays and leather inlays of lines, with gold and blind tooling. Terracotta blind-tooled goatskin doublures. Handmade leather endbands. Colored edges. Handmade Japanese endpapers. Title in gold on spine.

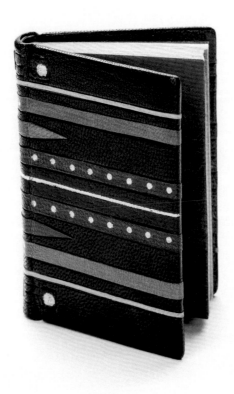

MARK COCKRAM

*A MIDSUMMER NIGHT'S
DREAM*
2009

Bound in full leather, with a secondary full-linen board attachment hand-printed and hand-colored. Leather and paper doublures, with leather-joined endpapers.

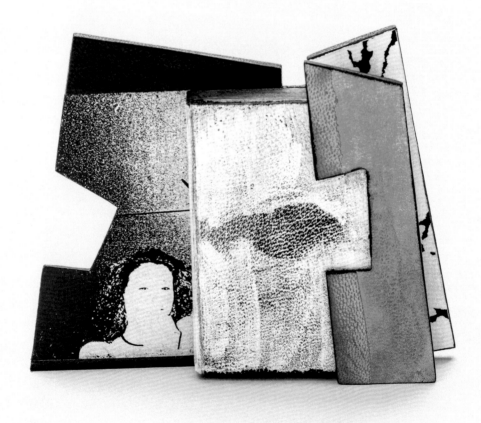

PART II: Knickerbocker's Shakespeare

I remember this book from my childhood. I liked to perform the role of Tom Snout the Tinker [the character in the play-within-the-play who performs the part of the wall separating the gardens of the lovers Pyramus and Thisbe]. It seemed natural for me to concentrate my design around the idea of the wall and the chink through which the lovers speak. I wanted to work within the sculptured aspect of the book and extend the available surfaces that can be worked on. The extended boards line up when the book is fully open to form the jagged edges of stone and brickwork.[42]

—Mark Cockram

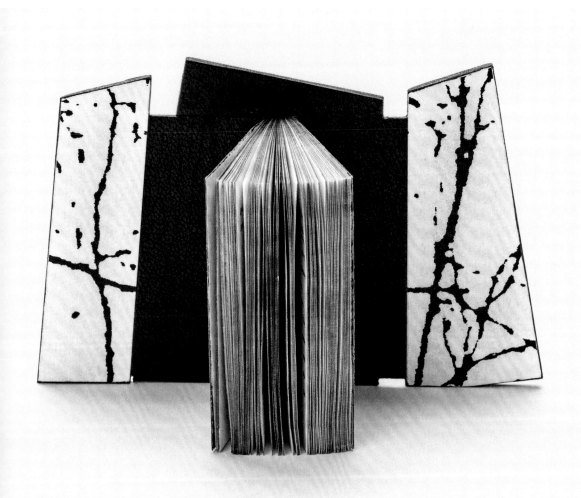

PAUL DELRUE

ROMEO AND JULIET
2005

Bound in tan, purple, lilac, blossom, yellow, rust, blue, and gray goatskin. Figures of Romeo and Juliet in undyed goatskin onlaid, with blind-tooled outline. Colored endpapers, suede flyleaves, and colored leather doublures matching the covers.

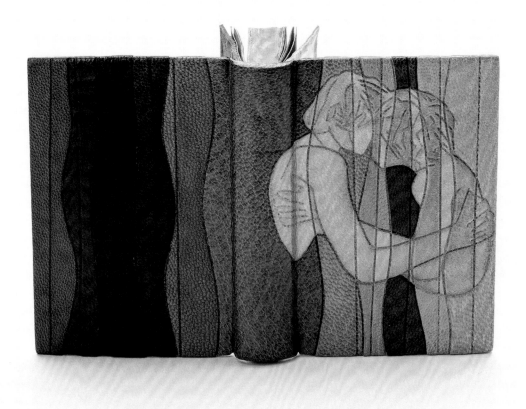

[This is] miniature binding number five, not many since I started as an apprentice in 1959.[43] You either love them or find them too fiddly; it is still a fight to work small. I trimmed by "press and plough"[44] and hand colored the edges using acrylics, again matching my colorful design on the covers. I treated Shakespeare as theater, as performance, as color.[45]

—Paul Delrue

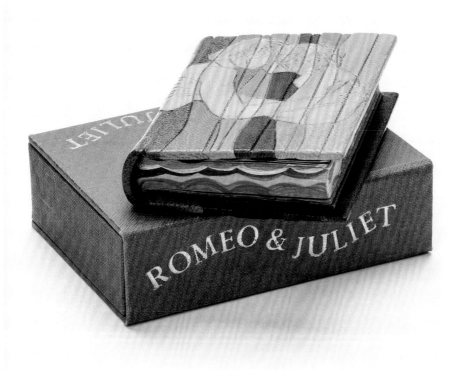

SÜN EVRARD

MUCH ADO ABOUT NOTHING
2005

Flexible staple binding in airbrush-dyed goatskin: six gold staples with amaranth wood bases holding text block and cover together. Twelve diamonds set in gold face the staples on both covers, backed with six golden discs on the inside. Two gold rods on fore-edge supporting the covers. Leather arranged in vertical bands inside the covers. Calfskin flyleaves.

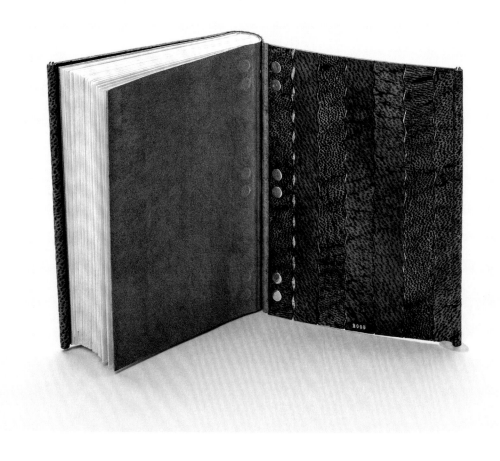

I have a problem describing this design. Everything about the text—the printing, the eventual illustration, the historical background, my feelings, my opinion—all this makes a sort of mixture in my head. I imagine something without really defining it, choose the structure, the leathers, the other elements. Then I start working, and the rest just unfolds. Sometimes I don't like it, and it goes to the wastebasket. Sometimes it changes, when I am halfway through the work, into something not planned. Design defines the techniques, and sometimes techniques modify the original design idea. I think bindings are not for illustrating a book—they accompany it.

—Sün Evrard

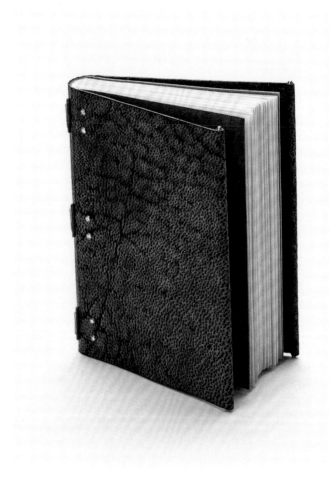

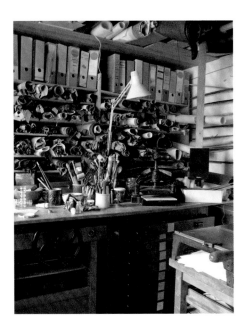

This is one corner of my—very small—atelier. You can see the rolls of different leathers on the shelves. When I buy leather, I always cut it to strips 25–45 cm wide, and have them split to 0.3–0.5 mm. I work with those like a painter would work with the tubes of paint, picking one, then another, trying to match colors and textures that would suit the atmosphere of the book I am binding.

Sün means hedgehog in Hungarian. It is a nice little name often used for children. It just stayed with me and it became official when I started to work as a bookbinder . . . a long time ago! My bindings are "signed" with the same hedgehog; but it is small, and I usually put it where it will not interfere much with the inside of the cover.[46]

—Sün Evrard

Bound in red goatskin, with red leather panels and gold decoration and titling.

ANDREAS GANIARIS

MEASURE FOR MEASURE
2006

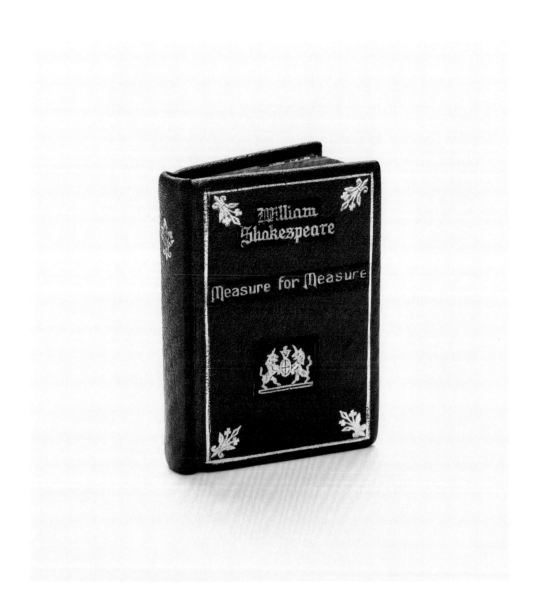

LUCIANO FAGNOLA

THE MERCHANT OF VENICE
2007

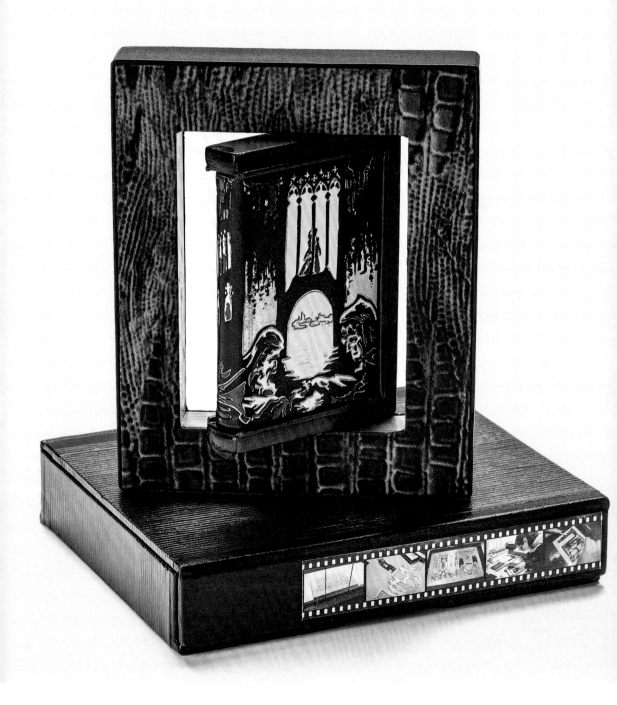

PART II: Knickerbocker's Shakespeare

Bound in leather, with leather inlays and onlays. Silk endpapers. Hand-trimmed black and gold headbands. Leather and silk frame. Box with images of the binding process, printed on paper on sides.

The project was the result of a collaboration between the binder, and the architect and illustrator Luca Bosio, who provided the original drawing.[47]

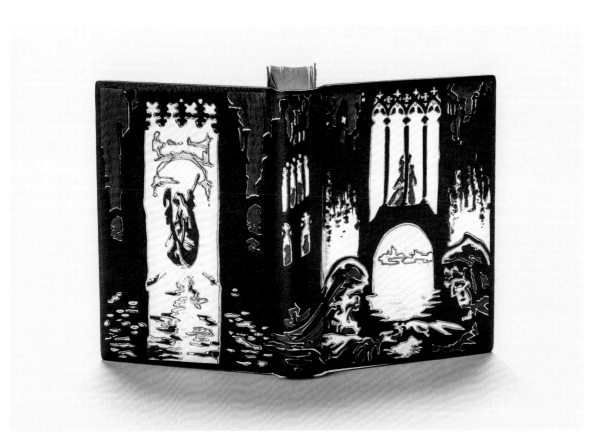

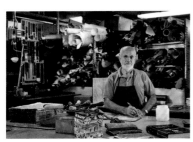

JENNI GREY

THE TAMING OF THE SHREW
2006

Bound in lilac suede, with glass and pearl beads hanging from silver wire, and silver clasp. Box made of sycamore with lilac suede linings sewn with glass beads.

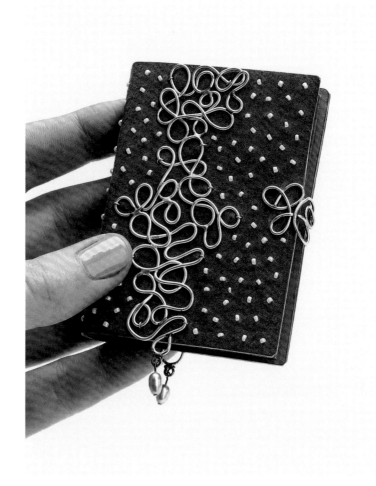

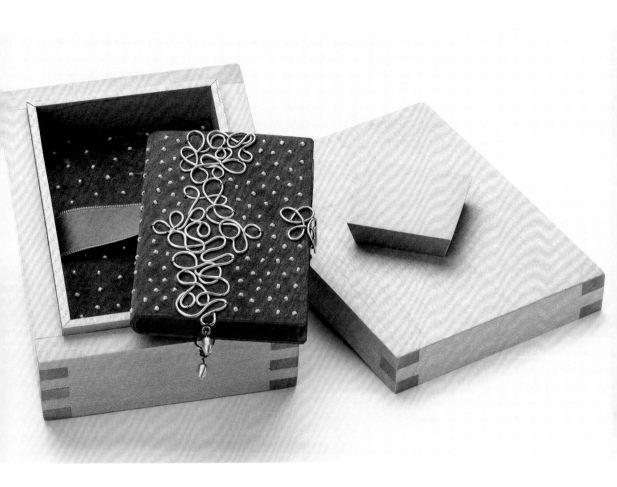

The design of the binding was developed from a contemporary response to the story. Rather than being perceived as a shrew, our heroine is admired for her feisty attitude—hence the lilac color of the cover, which has a rather more female than male quality but isn't too girly. The twisted wire is a reference to the influences suppressing her personality; no one stands up for her, and everyone is trying to turn her into someone else. The clasp reinforces this feeling of holding something in. Due to the nature of sterling silver, the wire will blacken with age, which could be seen as a comment on the play's message! The decorative beading alludes to our heroine losing her struggle to keep her identity and conforming to her traditional role. The outwardly plain box has beaded suede linings, to enhance the precious and fragile quality of the content.[48]

—Jenni Grey

ANGELA JAMES

THE COMEDY OF ERRORS
2007

Bound in green and orange airbrushed calfskin, with resist-colored onlays and letterpress printing. Undyed calfskin spine with black acrylic-ink stripes. Hand-colored flyleaves. All edges gilt. Interior with orange and green resist-patterned calfskin; hand-drawn and painted images on calfskin, with gold tooling. Box covered in orange airbrushed calfskin and lined with pale lime-green suede. Inside flap covered in lime-green airbrushed calfskin. Hole cut out and edged with patterned calf. Leather label with title set into lid of box, with painted stripes down sides.[49]

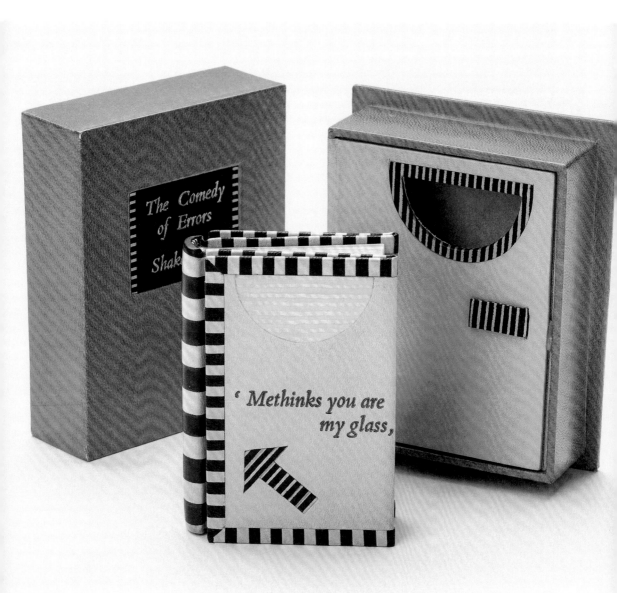

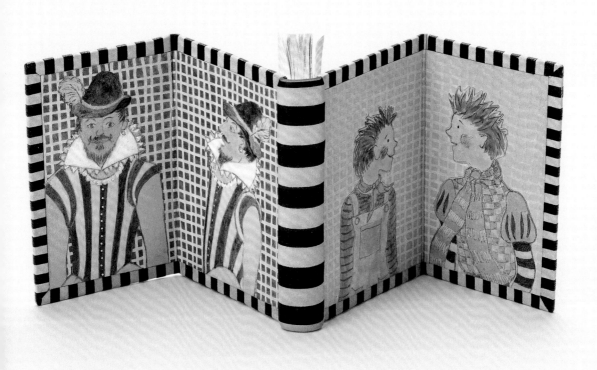

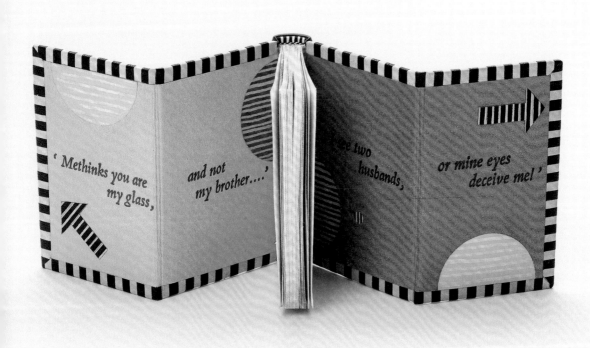

PETER JONES

KING HENRY VI, PART 1
2007

Bound in colored strips of leather and oak and walnut veneers, with leather-strip inlays. Japanese Mingei endpapers. Edges colored black. Oak box with paper linings and title label.

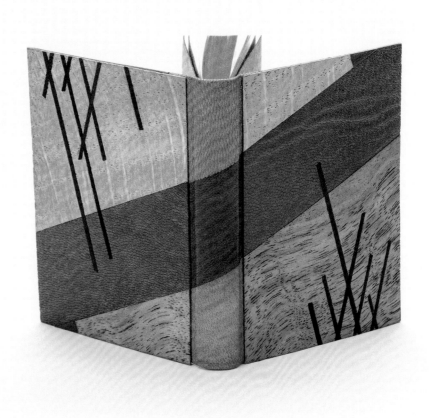

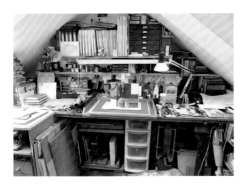

The design is based on the conflict between England and France in the fifteenth century. England is oak veneer, and France is the darker walnut. The English Channel is the blue leather. Spears and swords are represented by the inlaid strips of gray, black, and brown leather. Blood is symbolized by the small red leather inlays.

Miniature books pose their own challenges, mainly in developing a structure that will work well with small

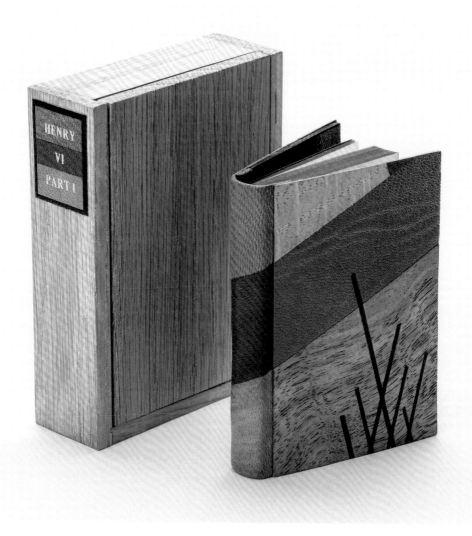

dimensions and lightness of materials. Everything needs
to be scaled down yet maintain sufficient strength and
integrity for the binding to remain sound. Equipment
designed for general use often needs to be adapted
for use with miniatures, or substituted altogether with
specially made alternatives. I find it interesting to work
through the problems of making a miniature binding,
and am still a little surprised that there is not much
saving in time over the making of a full-sized piece.[50]

—Peter Jones

The making of *King Henry VI, Part 1*, bound by Peter Jones, 2007.

1. Text block resewn onto linen tapes after removal of old covers.

2. Detail of sewing.

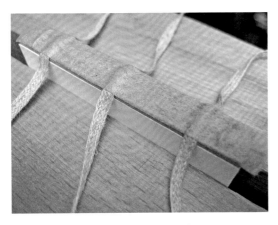

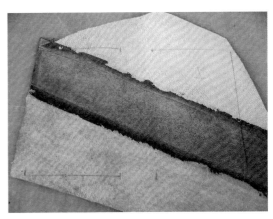

3. Spine lined with Japanese paper laid over linen tapes, in preparation for adding leather.

4. Leather pared for boards and spine.

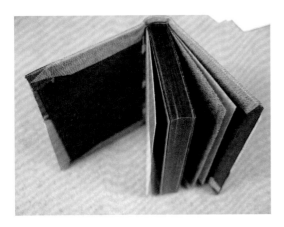

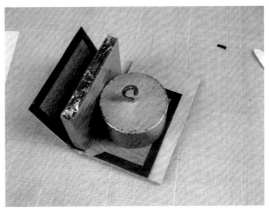

5. Boards and spine covered with leather. Edges of text block colored black.

6. Inner board joints covered with leather and trimmed for black leather edging.

PART II: Knickerbocker's Shakespeare

7. Grooves cut into wood veneer for leather inlays.

8. Leather pieces and wood veneers for outer covers.

9. Leather strip and wood veneers assembled for outer cover.

10. Paring the back of the leather using a spokeshave.

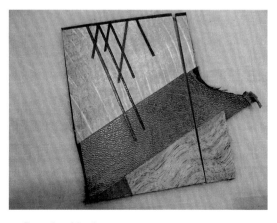

11. Completed back outer cover.

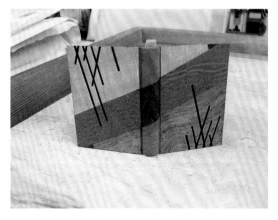

12. Completed binding.

GEORGE KIRKPATRICK

KING HENRY IV, PART 1
2007

Bound in leather, with embossed silver covers. Casket made of resin, board, and leather, with paint, gold, and palladium tooling.

This is one of a set, with each volume given to a different binder to interpret. . . . I chose Henry IV simply because I lived within a quarter-mile of his tomb at Canterbury Cathedral. . . . [It] is only because Shakespeare wrote two plays about him that he is remembered at all by most people. Thus when visitors today come to visit his tomb, it is the Shakespeare image of King Henry they come to in reality. Therefore, I decided to make a replica of the tomb, which, instead of the remains of King Henry, contains the hidden treasure of Shakespeare's play.[51]

—George Kirkpatrick

JEANETTE KOCH

AS YOU LIKE IT
2005

Bound in resist-dyed goatskin and vellum, with gold tooling. Gilt edges. Rust-colored Japanese endpapers. Silk endbands.

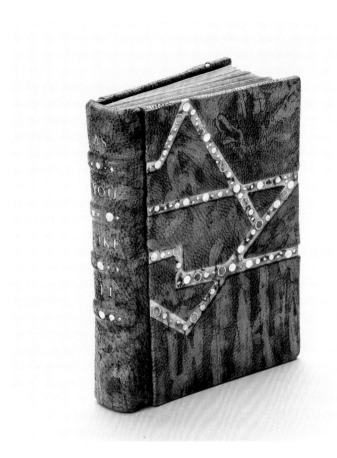

O Rosalind! these trees shall be my books,
And in their barks my thoughts I'll character.

—*As You Like It* (III, ii, lines 5–6)

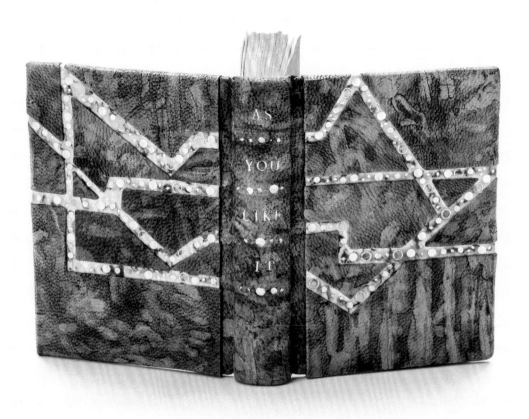

The resist-dye leather depicts the Forest of Arden. The boards are covered with vellum marked by pen-and-ink handwriting and gold tooling. Small cutout shapes, each covered with finely pared dyed goatskin, are placed in a pattern to expose four crisscrossing pathways on each board. These pathways depict the tortuous ways of the four pairs of lovers in the play, all of whom win their loves in the end, joining together on the raised wedding bands on the spine.[52]

—Jeanette Koch

MIDORI KUNIKATA-COCKRAM

TWELFTH NIGHT
2005

Bound in black and purple goatskin, decorated with handwoven strips of leather. Hand-dyed endpapers and doublures.

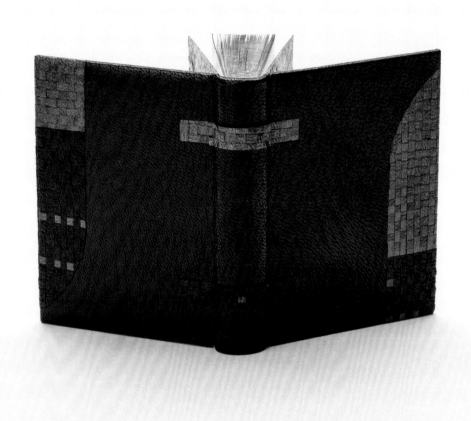

I chose two characters from this story for the design element: Olivia, one of the four leading characters, and her servant Malvolio. The binding is based on color: purple for Olivia and yellow for Malvolio. Though her life is blessed, she is beset with loss and confusion. This is interpreted with the interwoven strands of purple and black. Malvolio is represented by the yellow in the endpapers, evoking the yellow stockings he wears in the play.[53]

—Midori Kunikata-Cockram

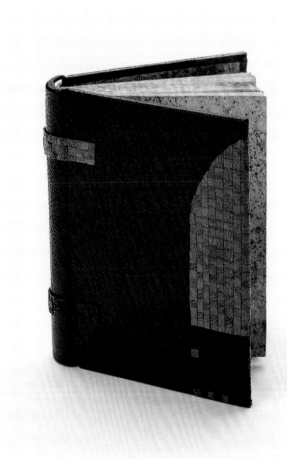

MIA LEIJONSTEDT

ANTONY AND CLEOPATRA
2005

Bound in black leather, with painted papyrus and black tooling. Box made of leather and silk, with snakeskin, semiprecious stones, and gold leaf.

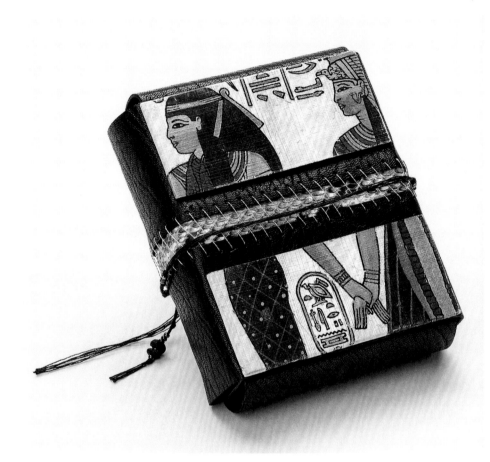

The concept started from the life of Cleopatra, which I then wanted to intertwine with the more European, Shakespearean visual style that would be a reference to Antony. The covers of the binding are black with black tooling, and in between there are slices of painted papyrus: the intertwined lives of Antony and Cleopatra, the feminine and masculine in one binding. The curved black tooling reflects the flowing poetic verses with which Shakespeare tells the story. The doublures of the binding are constructed in a similar fashion.

The wrapper box for the binding also displays the feminine and the masculine: the cover on the outside reflects Antony's side of the story, the inside of the box representing Cleopatra's tale. It is said that purple was Cleopatra's favorite color; therefore, the raw silk inside the box is purple. According to legend, Cleopatra was killed by a poisonous snake brought to her in a basket. This is represented by the rolled snakeskin in the bottom of the box, hiding underneath the binding. The box itself went through various incarnations so that I could get it exactly right. It was to be "fit for a queen," thus the frame of semiprecious stones (garnets) and gold. The base of the box has Egyptian painted papyrus depicting Cleopatra and the god of Death, with a band of snakeskin running through the middle showing the cause of her death. The box is like a tomb in which Cleopatra herself lies. The inside of the black leather wrapper has a crunched black leather strip running across it: another reference to mummy wrappings. The binding and the box together are almost like Cleopatra's personification—or something that could have belonged to her.[54]

—Mia Leijonstedt

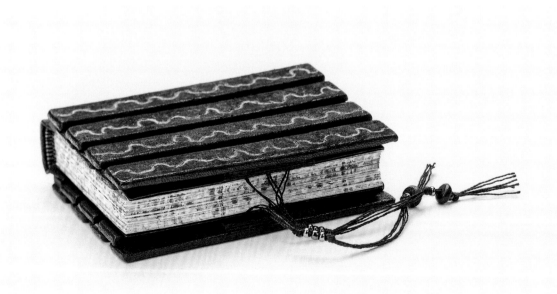

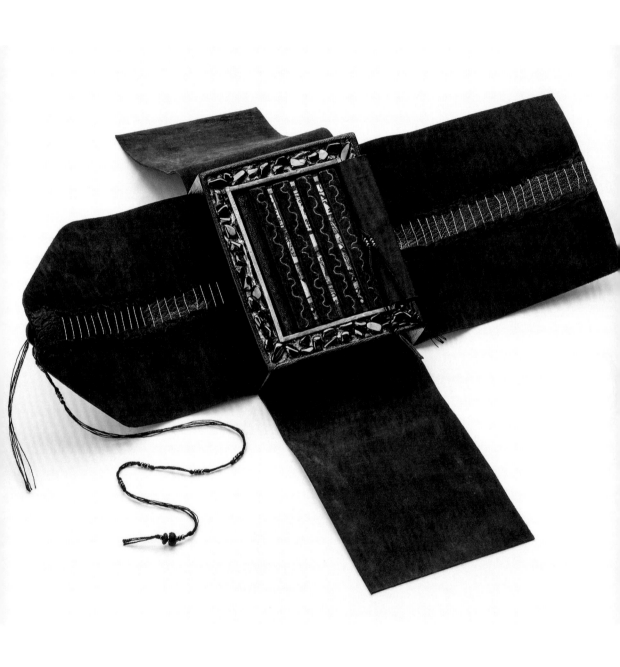

PART II: Knickerbocker's Shakespeare

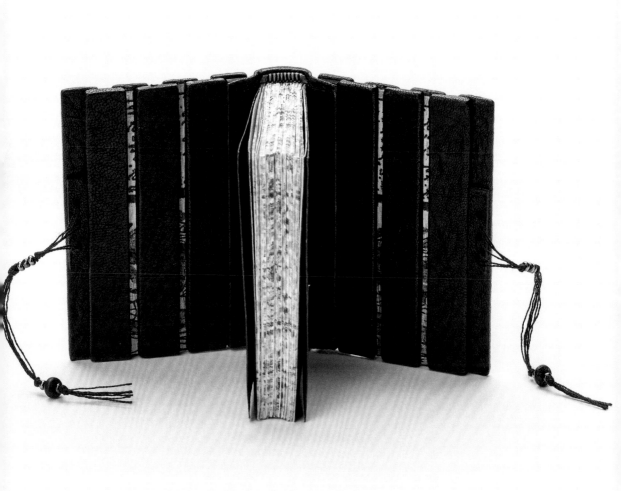

BERNARD MIDDLETON

KING HENRY IV, PART 2

2005

Bound in full black goatskin, with green and red onlays and gold tooling. Gilt edges. Black doublures and green flyleaves.

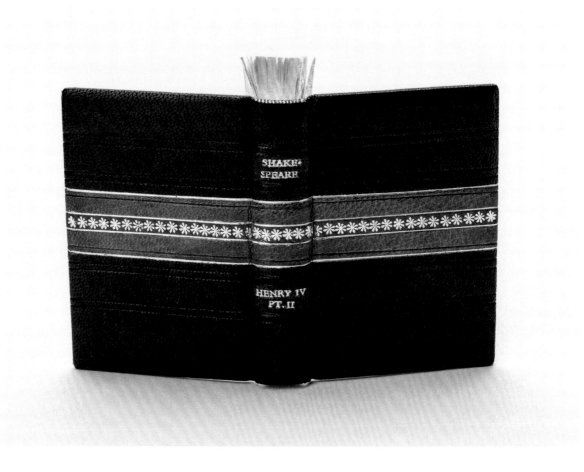

Bound in full black chagrin goatskin, with colored onlays and gold and palladium tooling. Title in gold on spine. All edges gilt. Marbled-paper doublures framed with a gold-tooled line; purple and gray suede flyleaves.

ELEANORE RAMSEY

MACBETH
2010

The whirlpools and flames represent the demise of Macbeth's kingdom. The whirlpool on the front cover is tooled in shades of purple, the back cover in shades of gray, and the flames in shades of green. Within the whirlpools are three sets of gold-tooled eyes representing the witches, or fates.

PART II: *Knickerbocker's Shakespeare*

The front and back covers have a cutout in the shape of a crown tooled in gold and palladium, with the positive shapes mounted on the flyleaves. With the book closed, the crowns are seen as part of the boards; when it is opened, the crowns appear to fall away, continuing the illusion of the downward fall of the kingdom.

The design for Macbeth required more time than usual to balance this famous text and my own aesthetic sense. Neale had asked if I would be interested in binding a Shakespeare play and he provided a list of choices. This is unusual, as ordinarily the choice of book is made by the collector. I chose Macbeth, knowing full well that even in its diminutive format, Macbeth remains a huge book.[55]

—Eleanore Ramsey

DAVID SELLARS

OTHELLO

2005

Bound in red oasis goatskin, with black vellum onlays. Four-layer front board, with three recessed, dyed pigskin panels and a central craquelle calfskin panel.[56] Title in red on black pigskin spine.

PHILIP SMITH

KING LEAR
2006

Bound in purple goatskin with leather onlays to create portrait of King Lear on front cover. Marbled-paper doublures; edges painted purple. Enclosure [bottom left] made of balsa wood covered in leather, modeled with resin and epoxy putty, and painted.

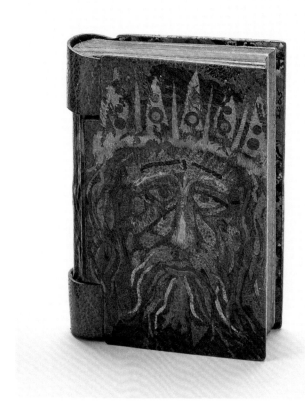

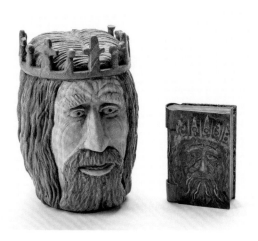

Miniature KING LEAR

by WILLIAM SHAKESPEARE — EDGES OF TEXT BLOCK PAINTED ORIGINAL CRIMSON.

MINIATURE COLLECTION

Published by KNICKERBOCKER LEATHER & NOVELTY CO. NEW YORK/UNDATED

2005 FOR MR NEALE ALBERT NEW YORK

✓ PRINTED OUT

SEPT 19, 20	'PULL' a 'TAKE DOWN' the book. THE BOOK IS NOT ORIGINALLY CUT SQUARE — FLIMSY PAPER needs OUTER FOLDS of SECTIONS guarding. CUT STRIPS of JAPANESE 'TISSUE' PAPER 9mm wide, lay on PVA [brushed on to plastic sheet] pick off with mounted needle tool. Lay guard glue side up on paper with fold made in it (A). Lay section with the two separated leaves to be guarded and draw the folded paper over the section taking the other side of the guard over on to the top loose leaf to be joined. TREAT ALL SECTIONS LIKEWISE. PRESS the loose sections in a pile after leaving overnight.
26 SEPT	Cut cream toned GOATSKIN PARCHMENT PAPER to slightly larger size than the book + fold two blank sections of 2 folios each [for front + back of book]. Then cut + fold two endpaper sections with gussets. Cut organdie strips + bond paper protective (waste) sheets + assemble the end sections. Also place organdie fold strengtheners as guards to SECOND END SECTIONS.
LAMINATED ORGANDIE JAP. PAPER LOOSE GUARDS.	LAMINATE SILK ORGANDIE TO JAPANESE PAPER (STRIPS) for LOOSE GUARDS AROUND FOLD OF SECOND SECTIONS (both ends of book) THESE WILL BE SEWN THROUGH WITH THE SECTIONS. (E)
27 SEPT	SET UP **2** narrow tapes on single BM sewing frame, and with one unsupported link stitch sewing station on fine linen thread (D) and sew the book.
28 SEPT	ROUND THE SPINE by PRESSING BETWEEN TWO SMALL 2.2mm MILLBOARDS cut to size for the book + bevelled on the HINGE EDGE (INSIDE FACE of BOARD) (E). GLUE UP AFTER ROUNDING. Make two fore-edge beams to the leaves at beginning of book, use same paper.
30 SEPT 1 OCT	sand paper the head + tail edges to remove coloured edges. plough the fore-edge that was longer (sloping to one end). Mix purple acrylic + paint the edges (dry in between separate edge treatments). Apply microcrystalline wax, brush + use lint free duster. The fore-edge is sandpapered to a slight round with a 1cm diameter rod/dowel.
2 OCT.	bevel the two boards with spokeshave + sandpaper 'stick'. slow bevel to .75mm at edges [2.2mm thick boards] checking squareness + use of squares [narrow]
3 OCT.	glue down the loose guard at back of book end section to 3rd section.
	cut Japanese tissue + apply two strips along the spine. cut on 'bias' a strip of thin cotton cloth + glue over spine on to waste sheet. Then glue another layer of Japanese tissue over the cotton lining (also lap on to waste sheet). PRESS EACH LAYER of spine lining with foam-plastic pad.
18 OCT.05	cut 'rebates' out of spine side of boards + bevel the slopes for feathering the yokes to the ¼ joints system. The yokes are made up of grey goatskin + Oyec 'soft' vellum. CUT and PARE PURPLE LEATHER FOR BOARDS.
19, 20 Oct.	glue one side of each yoke, leave under weights. when set dry glue other side [again glue the flyleaf/waste sheet to which the yoke will be attached] + press again. The yoke is forced into close contact around the spine but slight gap is left top + bottom of the yoke because of the slightly raised tape slips linings at head + tail.

INSIDE OF BOARD

YOKE RECESS deeper bevel

cushion + bevel

PULL DOWN TO FOLD GLUED GUARD TO SECTION
(A)

ACTUAL ANGLE

silk organdie

(B)

glued silk organdie guards.

45/3 THREAD

(D)

(C)

(E)

fore-edge shape (exaggerated here)

JAP TISSUE
COTTON

purple orange grey

feathered ends. purple

YOKES - HEAD CURVED

36

JAN SOBOTA

KING HENRY VI, PART 3
2007

PART II: Knickerbocker's Shakespeare

Bradel binding in brown goatskin, with gilt edges and gold tooling.[57] Hand-painted decorations on front and back covers in illuminated manuscript style. Box covered in dark-red goatskin, with hand-painted portrait of Henry VI.

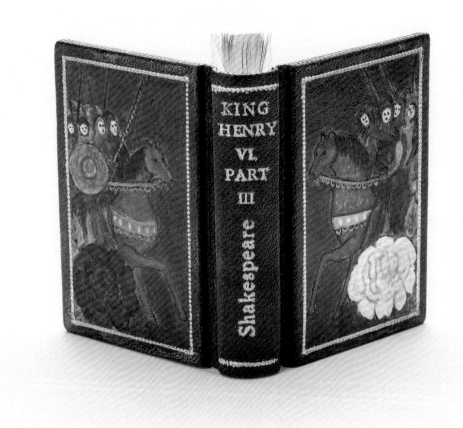

JARMILA JELENA SOBOTA

KING HENRY VI, PART 2
2007

Bradel binding covered with silver leather. Front and back covers contain original brass etched plates, with applied silver leaf. Graphite edges. Enclosure covered with silver leather with gold tooling.

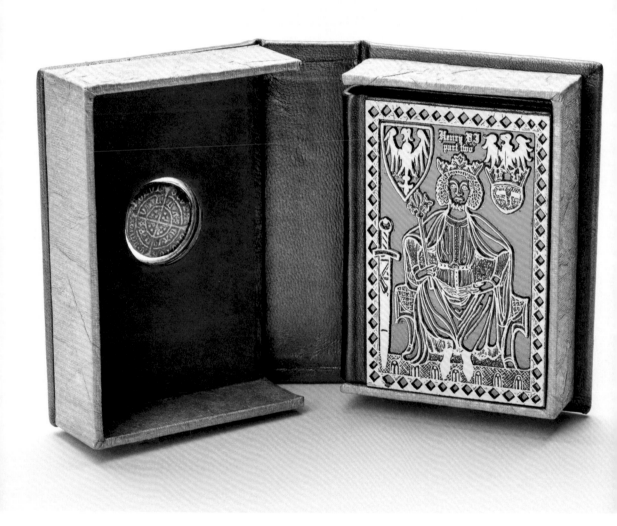

An illustration from the medieval manuscript known as the Manesse Codex inspired the design of the top board. The back design includes one of the most famous quotes from the play: "The first thing we do, let's kill all the lawyers." The front opening contains a replica of a half-groat, coinage used during the reign of Henry VI.[58]

—Jarmila Jelena Sobota

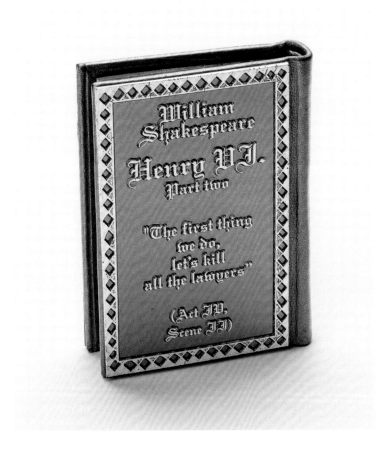

JULIAN THOMAS

THE TEMPEST
2004

Bound in calfskin, dyed and tooled in gold.
Top edge gilt.

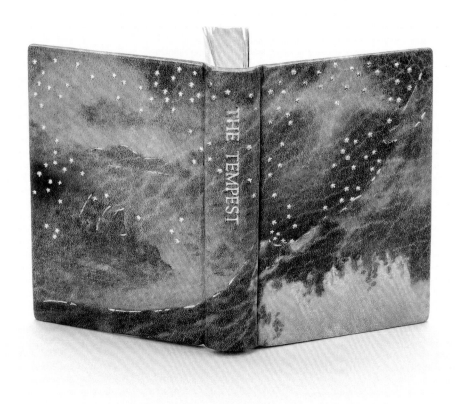

The design was developed from a small painting that was photographed, converted to black and white in Photoshop, reduced and photocopied. The image was then printed offset onto smooth calfskin using a solvent, before being painted using leather dyes. The book was covered in this leather before being tooled in gold.[59]

—Julian Thomas

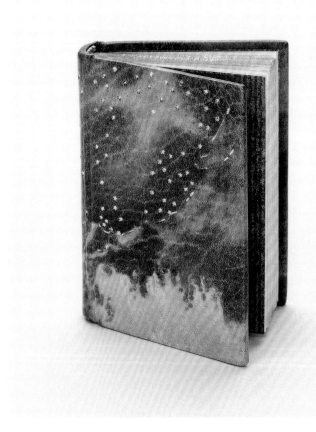

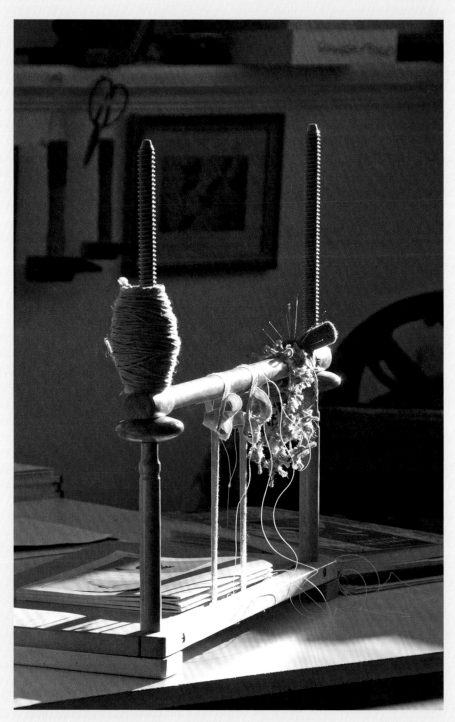

Sewing frame, Hélène Francoeur's studio, Québec, Canada, 2012.

PICKERING'S SHAKESPEARE

The Plays of Shakespeare, vol. 1, bound by Johanna Röjgård, 2007.

The Plays of Shakespeare
(London: William Pickering, 1825)

Neale Albert asked a group of designer bookbinders to rebind a Shakespeare set that was published in 1825 by William Pickering and issued in nine volumes. Several binders retained a few of the original details, such as the sewing or the gilt edges—Kaori Maki even incorporated the binding into her enclosure (p. 190)—but most dismantled their books and created wholly new housings and bindings.

HÉLÈNE FRANCOEUR

ROMEO AND JULIET;
HAMLET; OTHELLO
(VOL. IX)
2011

Bound in full calfskin, with gold and copper tooling.

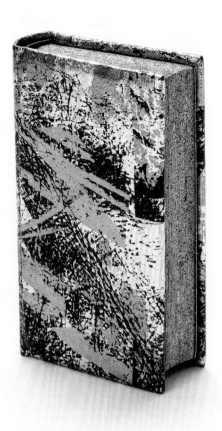

From the beginning, this miniature book seemed to be a jewel to me. So I treated it like that. I removed the tarnished gold on the three edges and tooled them anew in two shades of gold and one of copper (three colors on the edges: three plays in the book). Then I lightly sprinkled the three edges with burgundy dye. I pasted down gold and burgundy endpapers. I picked a piece of burgundy calfskin . . . and worked on tooling the same two shades of gold and one of copper over its surface. The endbands are made of that leather.[60]

—Hélène Francoeur

KATE HOLLAND

*KING HENRY IV,
PART 2; KING HENRY V;
KING HENRY VI, PARTS 1
AND 2* (VOL. V)
2009

Bound in full dark-green Harmatan goatskin, with gilding and multiple pierced holes revealing multicolored paper underneath. Original gilt edges. Green leather headbands. Gold paper doublures and endpapers.

The design represents the British and French armies drawn up in battle ranks. To the outer reaches, the troops are resplendent in their respective red and blue uniforms, glittering with gold trim. As they meet in the center, the numbers reduce, the gold is worn away, and the colors meld to a blood red.[61]

Surprisingly to me, a smaller text block size doesn't shorten the time needed for designing and binding very much. It is, of course, much more fiddly than binding a conventionally-sized book. I always find it tricky to choose material for the boards for miniature books. It has to be thin and heavy enough to close, so I tend to laminate thin material that also has substantial weight.[62]

—Kate Holland

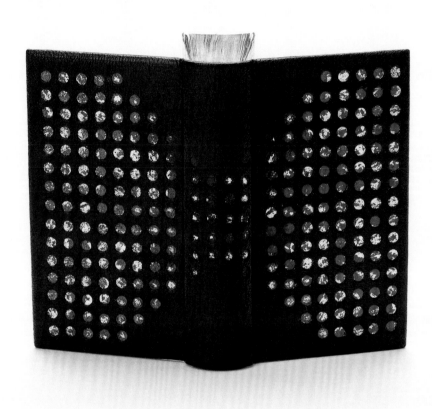

TOM McEWAN

CYMBELINE; TITUS ANDRONICUS; PERICLES, PRINCE OF TYRE; KING LEAR (VOL. VIII)

2011

Bound in goatskin, with transfer-print design augmented with hand painting and blind- and gold-tooled lines. Edges with gold tooling, flaked gold, and acrylic inks. Endpapers and flyleaves are a combination of transfer printing, hand painting, gold tooling, and flaked gold on Japanese paper.

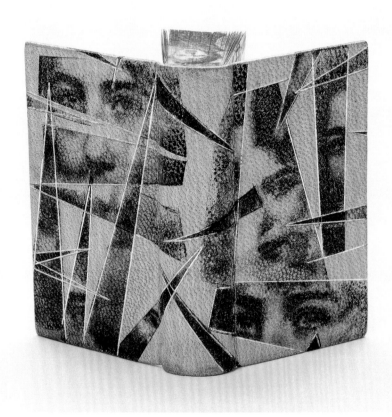

The design is based on some of the more disturbing aspects of *Titus Andronicus*, in particular the fate of Lavinia, who has her tongue and arms severed in an attempt to force her silence.[63]

—Tom McEwan

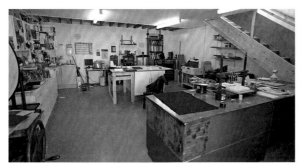

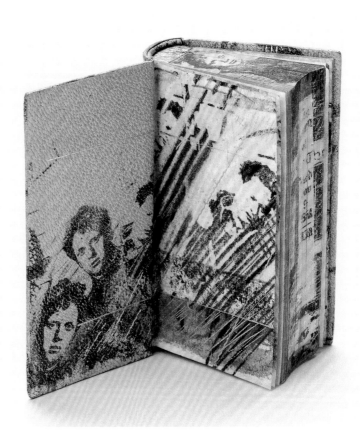

KAORI MAKI

AS YOU LIKE IT; ALL'S WELL THAT ENDS WELL; THE TAMING OF THE SHREW; THE WINTER'S TALE (VOL. III)

2012

Bound in tooled green goatskin, with onlays. Box incorporates original spine and covers.

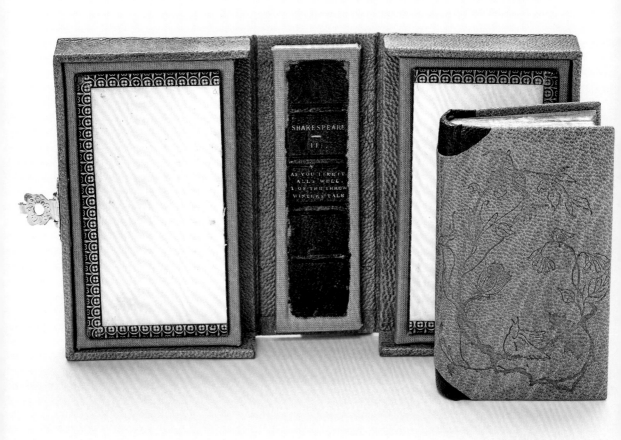

Bound in red Harmatan goatskin. Title and initials blind tooled, set off by parallel blind-tooled lines spanning cover from top to bottom and continuing across doublures. Headbands embroidered with red and gold. Housed in silk-lined slipcase, covered with blind-tooled red goatskin.

FRANKLIN MOWERY

THE COMEDY OF ERRORS; MACBETH; KING JOHN; KING RICHARD II; KING HENRY IV, PART 1 (VOL. IV) 2007

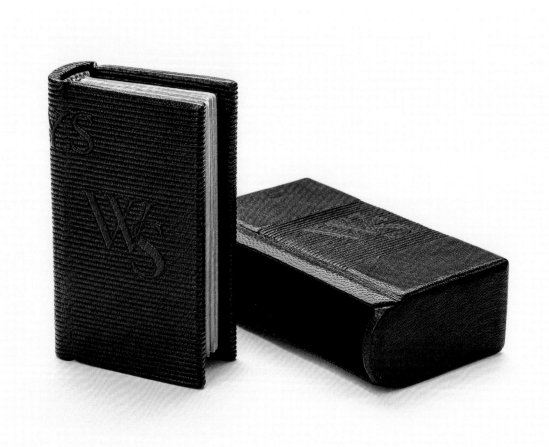

NICKY OLIVER

KING HENRY VI, PART 3;
KING RICHARD III; KING
HENRY VIII; TROILUS AND
CRESSIDA (VOL. VI)
2011

Bound in hand-dyed goatskin, with gold onlays and foil tooling. Hand-dyed leather joints. Hand-sewn red and black silk headbands. Red acrylic wash and gold leaf applied to edges of text block.

This volume includes four of Shakespeare's works. In studying each of them, I noted their common themes: royalty, bloodshed, power, corruption, greed, and murder. I wanted to create an intensity, marrying all of these themes by applying layers of red, using a splatter technique to illustrate violence. The small gold leather onlays with the gold-foil dots on the covers symbolize royalty or the crown. The endpapers and the doublures have a repeated pattern of a stiletto dagger.

I usually start my design process on large sheets of stretched paper after having studied the text. I use big movements, big brushes, and lots of inks and paints. I had to change everything. I had to always check that what I was doing would work in a smaller format by making a small "window" frame. The binding techniques were the same but I had to move less.[64]

—Nicky Oliver

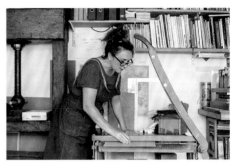

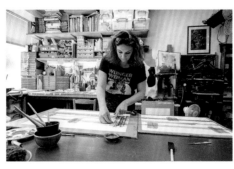
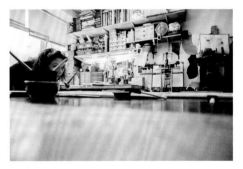

JAMES REID-CUNNINGHAM

TIMON OF ATHENS;
CORIOLANUS; JULIUS
CAESAR; ANTONY AND
CLEOPATRA (VOL. VII)
2011

Pierced-vellum binding with goatskin spine. Original sewing and gilt edges retained; new laid endpapers. Front bead silk endbands. Tooled in gold and colored foil. Gold lettering on black goatskin "pull strap" across spine.

The characters and scenes in Shakespeare's plays are so well known that a binding can only be original if it is completely abstract. My Shakespeare binding is a non-objective balance of bright circles and vertical lines. The circles are the small worlds of Shakespeare's plays, and the lines are the forces propelling the characters. The colors are bold and clear, apparently lacking the dark subtlety of Shakespeare's plays. The binding is bright and inviting, but the meaning is uncertain, even cryptic.

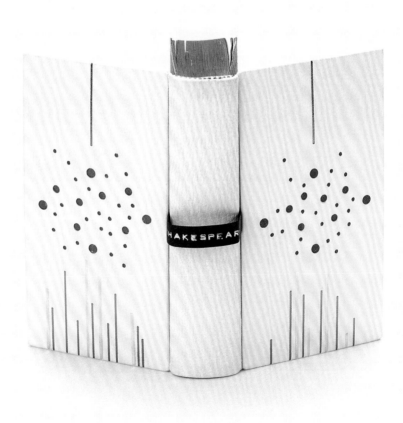

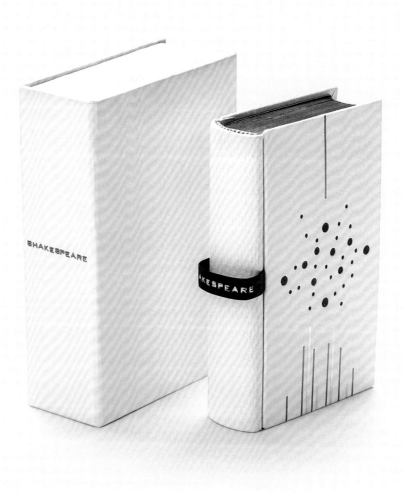

One element of this binding that everyone finds unusual
is the black strap across the spine. It is my version of the
"pull strap," something that binders used to put onto large
newspaper and atlas bindings in the early twentieth century
so it would be easier to pull the book off the shelf. I
thought a pull strap would be an amusing addition to a
miniature binding.[65]

—James Reid-Cunningham

JOHANNA RÖJGÅRD

*THE TEMPEST; THE TWO
GENTLEMEN OF VERONA;
A MIDSUMMER NIGHT'S
DREAM; THE MERRY WIVES
OF WINDSOR; TWELFTH
NIGHT* (VOL. I)
2007

Bound in goatskin and sheepskin, with colored papers separating each play. Original gilt edges. Original illustrated title page removed to a folder to be laid into the box, with Shakespeare's portrait seen through a slice of mica. Decoration on the enclosure recalling the timbers and whitewashed walls of the exterior of Shakespeare's Globe Theatre in London.

Dear Neale
Please enter slowly
The Globe
Salute Mr. Shakespeare
Enjoy the colors and choose a play.[66]

—Johanna Röjgård

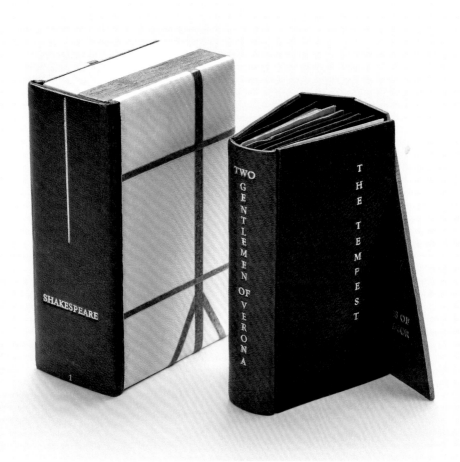

PART III: Pickering's Shakespeare

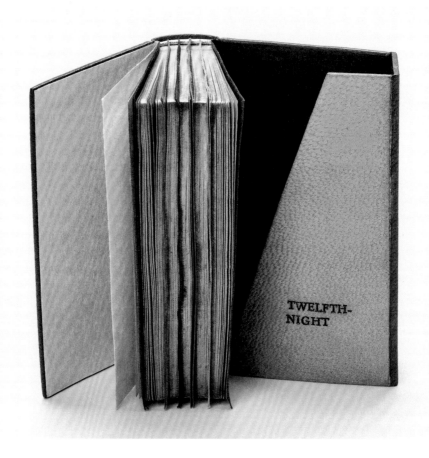

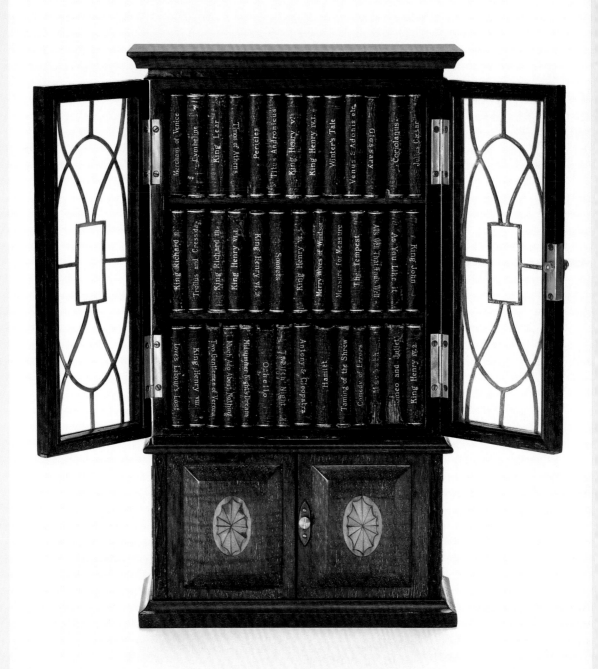

Bookcase, 11⅛ x 8½ x 4½ in., housing *The Plays of William Shakespeare*, 40 vols. (Glasgow: David Bryce and Son, 1904).

MORE SHAKESPEARE!

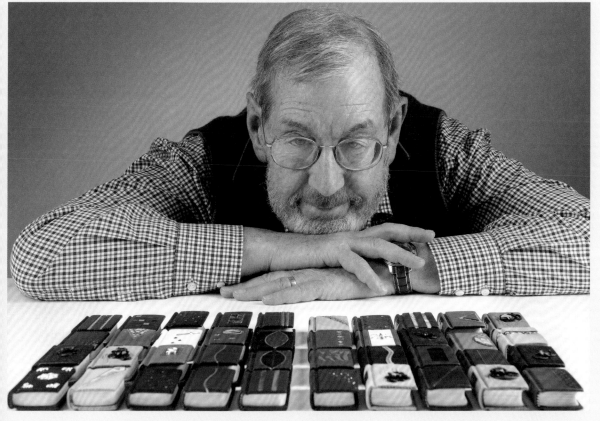

Neale Albert with *Works of William Shakespeare*, 40 vols. (London: Allied Newspapers, 1904), bound by Jana Přibíková, 2005.

Additional Shakespeare-Related
Works in the Collection of Neale and
Margaret Albert

Collecting is an addiction. Impossible to stop.
—Neale Albert

MARYLINE POOLE ADAMS

Presenting The Seven Ages of Man by Mr. William Shakespeare (Berkeley, CA: Poole Press, 1994)

Miniature movable book issued in a box made to resemble the Globe Theatre.

MARYLINE POOLE ADAMS

St. Crispin's Day by William Shakespeare (Berkeley, CA: Poole Press, 2009)

Bound in red suede.

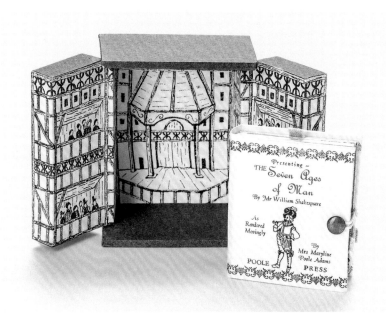

MARYLINE POOLE ADAMS

Hamlet, Prince of Denmark: Moving Moments in the Play by William Shakespeare (Berkeley, CA: Poole Press, 2005)

Miniature movable book issued in a box made to resemble a castle.

SUSAN ALLIX

Flowers from Shakespeare
2002

Bound in emerald-green goatskin, with onlays of fine, wavy, horizontal pink lines across both boards and titled in black on pink, with matching dark-green leather doublures and Japanese endpapers; pink and emerald silk endbands. Edges stained light green with darker green dots. Slipcase in the form of a silver cage, with a silver jasmine flower set with a green tourmaline center.

This binding is one of a series in which silver is used in different ways. The small format of the book, combined with the fact that it contained etchings printed on paper of some substance, meant that the boards might not close well. I devised a silver cage that would hold the boards closed and act as a decorative part of the cover.

The idea for the binding came from a jasmine with white flowers and bright-green centers that I saw hanging over a pink brick wall. Although I aimed at keeping the cage as simple as possible, it soon came to dominate the binding itself and demand a smooth and simple structure for the book. The problem was to keep the two parts working together while maintaining a binding that had some sparkle when it was taken from its container. The brilliant green leather and green dots on the edges picked up the color of the tourmaline, and the only other color allowed was the pink of the wall.

I honestly can't remember if I wanted to make a cage or was having doubts (once more) about structure; probably a mixture of both. But once I had thought about a cage, I had to try it. And it went through several variations, each one to be fitted to the slight binding variations of its book. I remember this particular cage because of a small drama: The setting of the stone was the last task after the book and cage had been made, and I dropped the tourmaline on the old wooden workshop floor; everyone was crawling around, and luckily it was found.[67]

—Susan Allix

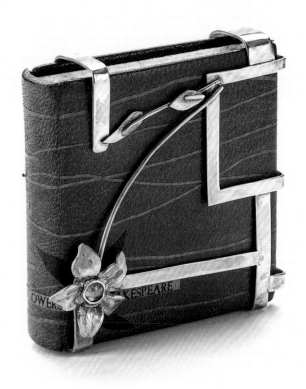

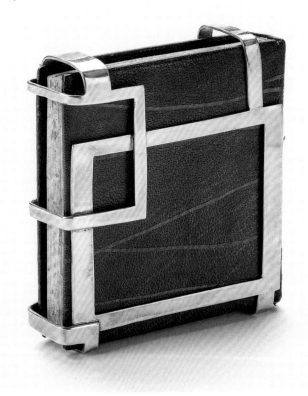

SUSAN ALLIX

Feste's Songs

2001

Bound in full black leather with dark blue doublures, onlaid with bright blue squares and closed with silver clasps, with blue Japanese flyleaves and French marbled endpapers.

When that I was and a little tiny boy,
 With hey, ho, the wind and the rain,
A foolish thing was but a toy,
 For the rain it raineth every day.

—Feste's song, *Twelfth Night*
(V, i, lines 378–81)

The books contain a selection of Feste's songs from *Twelfth Night* by William Shakespeare, printed by me in letterpress on handmade paper. The books rest in a black leather mausoleum, its construction symbolizing the transition in the poems from little boy to corpse. "The Book of Youth" is on top in a specially made silver box lined with blue suede (a reference to silver gifts given at birth). "The Book of Death" is enclosed in a silver-fronted drawer at the base. The mausoleum is covered in black crocodile [leather], and rests on a black granite slab. The title is reflected in a mirror on the upper tier.

I was making a small silver box and, finding it quite diffi-cult, I thought "This is a foolish little thing to be doing." Of course, Feste's song then came to mind ("A foolish thing was but a toy"), then the idea of a tiny book in the box, then following his songs through life until he was laid to rest—from the foolish silver toy to the black granite stone. This book took ages to complete, and some years of persuasion from Neale before I parted with it.[68] I printed two copies in case of mishaps, so the second bindings [opposite] were of less complicated thoughts.

PART IV: More Shakespeare!

SUSAN ALLIX

Feste's Songs

2007

Smaller book: Bound in black goat-skin with gold wire, blue square onlay on the front cover, and blue endbands. With leather doublures, marbled endpapers, and blue flyleaves.

Larger book: Bound in gray goatskin, with black and blue onlays, and tooled with a single gold curve. With black Japanese-paper doublures, marbled endpapers, and blue flyleaves.

The books—another copy of *Feste's Songs* (2001, p. 204)—are contained in a double half-slipcase covered in black leather. A square of opaque ultramarine-colored plexiglass is mounted on the larger part of the case, partly covered by the smaller slipcase. When the books are fitted together, the curved gold clip makes a reflection in the glass and rises up like the note of the song. The whole is contained in a black-cloth box that carries the title and is lined with ultramarine-suede cloth.[69]

—Susan Allix

ROBERT BARIS

Shakespeare Songs (Shaker Heights, OH: Wind and Harlot Press, 1982)

NOT PICTURED

BAYNTUN-RIVIERE

Shakespeare's Comedy of Twelfth Night, or, What You Will by William Shakespeare. With illustrations by W. Heath Robinson (London: Hodder and Stoughton, 1908)

Bound by Bayntun-Riviere, 2011, in full dark-blue goatskin, with decorative gold borders on the boards enclosing a gilt panel, and a heavily decorated spine with gold titling and panels.

NOT PICTURED

BIBLE

The Holy Bible: Containing the Old and New Testaments. With Shakespeare's Family Records in Facsimile (Glasgow: David Bryce, 1901)

PICTURED BELOW

JO BIRD

Venus and Adonis (Harrow Weald, Middlesex: Printed by R. A. Maynard and H. W. Bray at the Raven Press, 1931)

Bound by Bird, 2013, in pale-biscuit goatskin with a dark-gray goatskin spine. Calfskin onlays hand-dyed in various shades of red. Carbon tooling on both boards and spine. Shown with *Brush Up Your Shakespeare*, bound by Haein Song, 2010 (p. 113).

PICTURED OPPOSITE

SMALLEST BIBLE IN THE WORLD WITH SHAKESPEARE'S FAMILY RECORDS IN FACSIMILE FROM THE PARISH REGISTER Holy Trinity Church Stratford-upon-Avon.

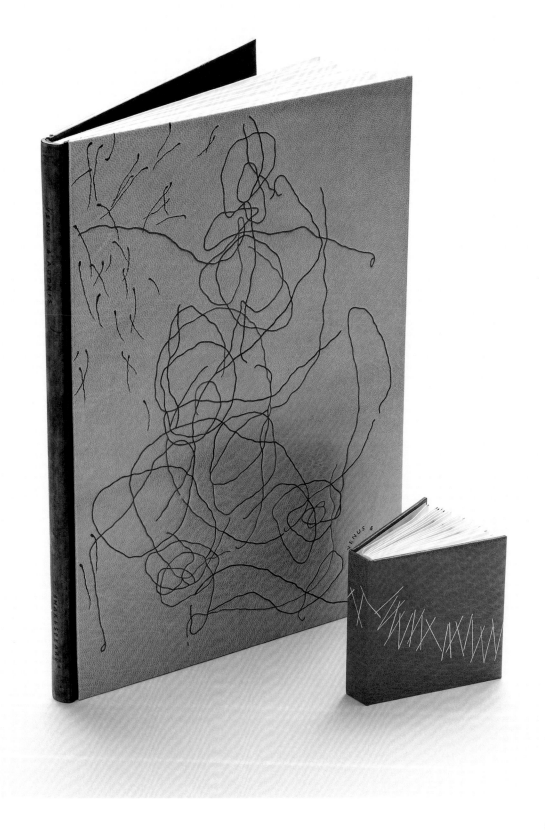

BARBARA BLUMENTHAL
LESTER CAPON

Shall I Die? Shall I Fly? (Boston: Anne and David Bromer, 1986. Printed by Firefly Press, Boston)

Bound by Barbara Blumenthal, 1986, in full blue goatskin, with purple onlays and gold-stamping of the title on both covers, after a design by Donald Glaister.
OPPOSITE LEFT

Blumenthal (shown below, right, with her studio at left) had the dies made for stamping the leather onlays and the title, and she worked with both Glaister and Suzanne Moore to select the leathers and papers that were used.

Bound by Lester Capon, 1986, in full crimson goatskin, with typographic design on covers incorporating the gold-stamped letters of the title. Spine with black goatskin onlay, with author's initials tooled in gold.

The cover design evokes the tumultuous indecision experienced by the poem's narrator.
OPPOSITE RIGHT

From an edition of 160 copies, this is the first miniature printing of this lyric poem, which was first attributed to Shakespeare in 1985 by the American scholar Gary Taylor. The bindings illustrated here are two of the thirty-five deluxe copies commissioned by the publisher Anne Bromer. Both have hand-illuminated initials in gold and watercolors by Suzanne Moore.

STEPHEN BYRNE
MARIAN BYRNE

Shakespeare's Flora (Huddersfield, West Yorkshire: Final Score, 2010)

Bound in green leather, with an inset embroidered panel. The text consists of Shakespeare quotations about flowers; each is accompanied by a hand-painted illustration of the pertinent flower. The pages are vellum, with inkjet-printed text.

The division of labor for both of these titles—as in most of our books—is that Marian does the research, embroidery, and painting, and I do the layout, printing, and binding. The embroidery is done entirely freehand, so no two covers are exactly the same. We work closely together at all stages of development, and continually discuss the progress as the books take shape so we can adjust our ideas as necessary.[70]

—Stephen Byrne

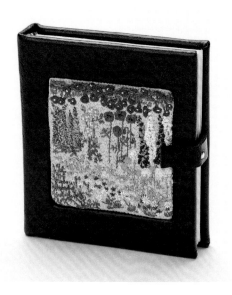

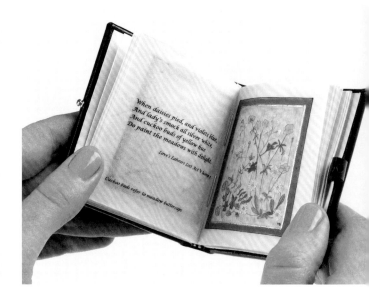

STEPHEN BYRNE
MARIAN BYRNE

Shakespeare from the Heart (Sorbie, Scotland: Final Score, 2015)

Heart-shaped book bound in red Pentland goatskin, with embroidered panel. Text from Shakespeare's writings on love, with hand-painted flowers.

NOT PICTURED

STEPHEN BYRNE
MARIAN BYRNE

Shakespeare to Music (Huddersfield, West Yorkshire: Final Score, 2011)

Bound in black leather, with inset embroidered panel depicting Shakespeare.

Concertina-fold book containing ten of Shakespeare's songs set to music contemporaneous with the text, each with tipped-in hand-painted illustration depicting some aspect of the song. Music set using Sibelius software and printed on an inkjet printer.

PICTURED BELOW

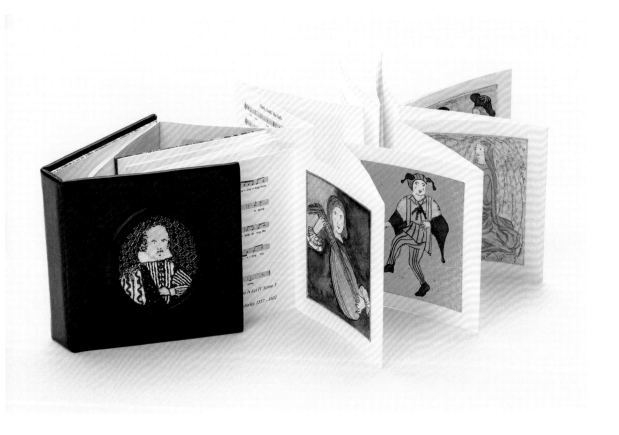

GABRIELLE FOX

Queen Mab

(Cincinnati: Squiggle Dot Press, 2007)

Bound in full goatskin, with leather onlays and gold tooling, full leather doublures, and flyleaves. Illustrated with Fox's original wood engravings. Additional suite of prints on Japanese chirimen paper enclosed in box and portfolio covered with Japanese cloth, with gold-stamped leather labels. Number one of an edition of forty-five.

The binding was inspired by the gates at the new Globe Theatre in London, and the leather doublures and endpapers have a design that echoes the ceiling of the stage. Shakespeare's Queen Mab steals in during the night. Her nature is reflected in the paper, engravings, and printing, housed in the traditional binding. The Japanese paper for both the printing and wood engravings is very fine—thin and translucent. The metallic text floats on the page, and the engravings can be seen from both sides of the paper.

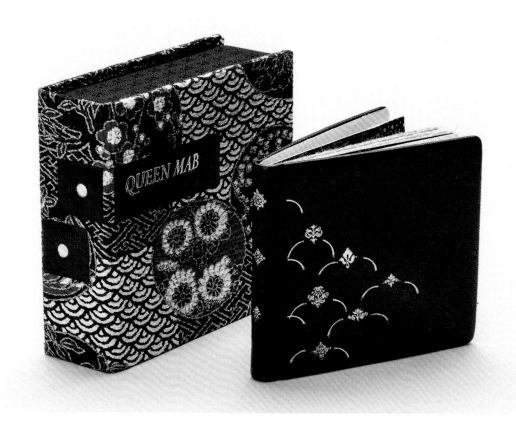

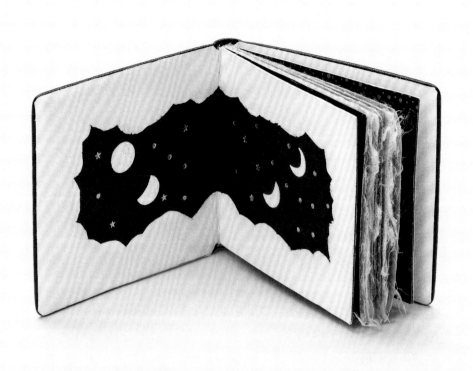

The tooling on this binding was more difficult to do than for a full-size binding. The more ornate patterned brass tools can be hard to line up once the gold leaf is applied. One must also be very careful not to press too hard or use tools that are too hot. The fine lines in some of these tools can cut through the leather easily.[71]

—Gabrielle Fox

DONALD GLAISTER
SUZANNE MOORE

Brush Up Your Shakespeare

2012

Bound in leather by Donald Glaister, with calligraphic text, illumination, and watercolors by Suzanne Moore.

This manuscript version of the song "Brush Up Your Shakespeare" was commissioned by Neale Albert.

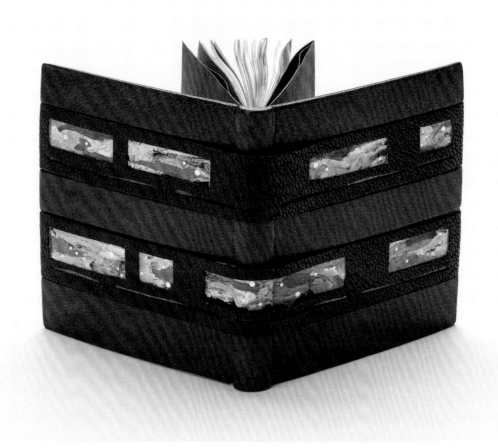

PART IV: More Shakespeare!

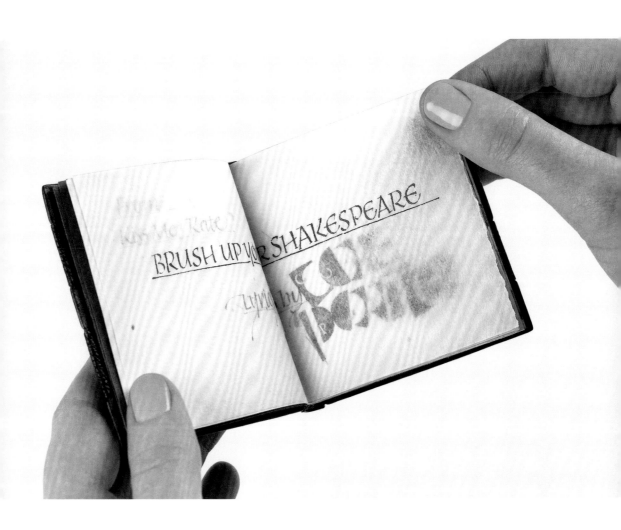

GEORGE KIRKPATRICK

The Tempest (Canton, NY: Caliban Press, 2001)
2013

Bound in dark-green leather, with colored-leather onlays on front and back covers, and silver and stainless steel wire.

Neale gave me this book to bind, which was lovely. But because the text is strongly designed in a way, it doesn't allow a great freedom. So I struggled with it until I found a way to put it all together with my own ideas.

The major problem is that I have not fully recovered from my major stroke [in 2009]. It has been difficult to read and write again for several years. I am still recovering from it. But Neale was really keen for me to work again, and he more or less "forced me"—in the nicest way—to enter the binding into a competition, which seemed so impossible. But he kept encouraging me.[72]

Even when you have a major stroke, when the doctors told the family I would never read or write ever again, you can still remember and dream, and have your imagination.

I made this second binding of *The Tempest* for Neale, and when I gave it to him, I didn't let him know that I made a little joke. I had made a few little drawings of him when he wasn't noticing. And so on the back binding I signed my name, but I also added a little figure dressed in Shakespeare clothing, really a portrait of Neale [p. 239]. I did it because it was fun but also because it was a huge challenge for me, and Neale Albert is the one who kept me running for all these years.[73]

—George Kirkpatrick

GORDON MURRAY

Sonnets Five (Bexhill-on-Sea, England: Silver Thimble Books, 1986)

Bound in pink cloth. Needlepoint panel of flowers and leaves inset on front cover. Hand-colored endpapers.

GORDON MURRAY

Cleopatra's Barge (Bexhill-on-Sea, England: Silver Thimble Books, 1990)

Bound in green cloth. Gordon Murray's calligraphic text in both books is embellished with watercolors and illuminated letters.

NEW THEATRE ROYAL, BRISTOL

Six playbills issued by the New Theatre Royal, Bristol (Bristol: Printed at the Bristol Mercury and Daily Post Office, 1871–78).

Performances include *Hamlet*, *Othello*, *Macbeth*, *As You Like It*, *Richard III*, *Romeo and Juliet*, and *Much Ado About Nothing*, starring notable actors of the period.

JANA PŘIBÍKOVÁ

Works of William Shakespeare, 40 vols. (London: Allied Newspapers, 1904) 2005

Bound in goatskin and decorated using a variety of techniques and materials, including gold and silver tooling; snakeskin and goatskin onlays; and marbled paper.

Measuring just over two inches high, each volume was originally published by Allied Newspapers in a plain leather binding. Přibíková rebound each volume in a different decorative binding.

PICTURED ON OVERLEAF

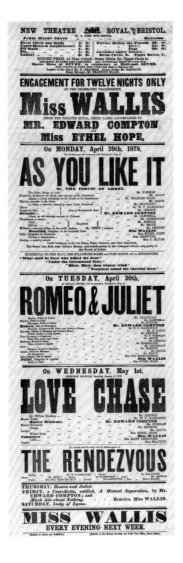

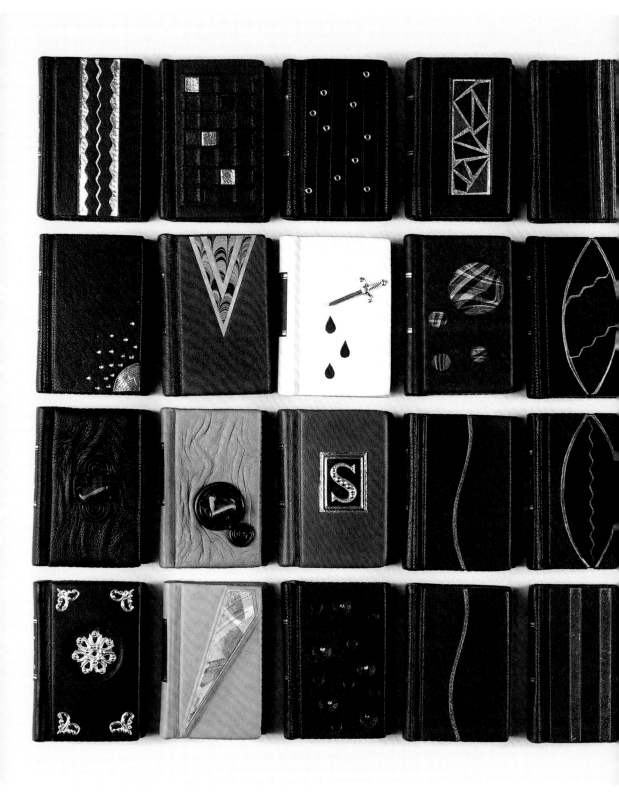

PART IV: More Shakespeare!

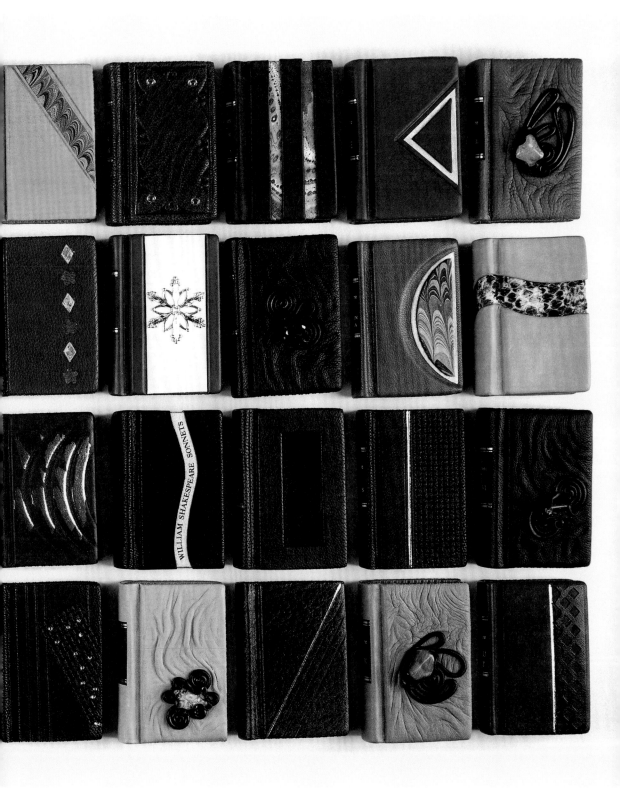

TRACEY ROWLEDGE

Essays on Shakespeare's Dramatic Characters of Richard the Third, King Lear, and Timon of Athens. To Which are Added an Essay on the Faults of Shakespeare, and Additional Observations on the Character of Hamlet, by William Richardson (London: Printed for John Murray, 1784)

Bound by Rowledge, 2007, in semi-limp handmade paper, hand-colored and tooled with gilt stars.

PICTURED AT RIGHT

UNKNOWN BINDER

William Shakespeare, *Shakespeare's Popular Dramatic Works*, 3 vols. (Newcastle upon Tyne, England: Printed and sold by J. Mitchell, 1810–11)

Bound in original quarter calf with marbled boards.

NOT PICTURED

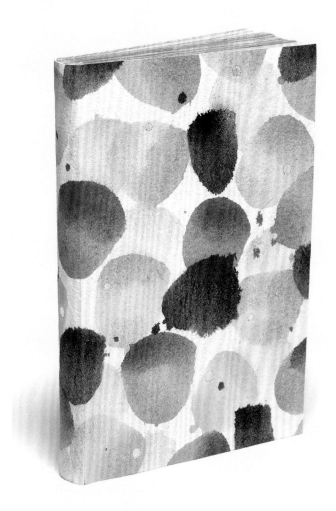

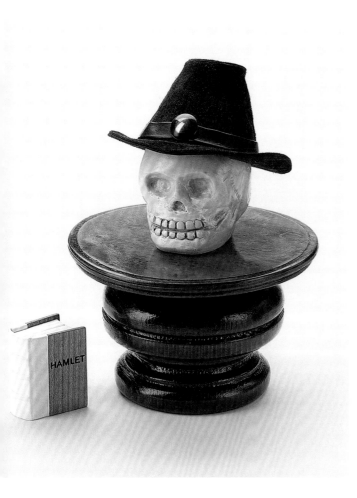

JAN SOBOTA

Hamlet (Loket, Czech Republic: Printed by Jan and Jarmila Jelena Sobota, 2009)

Bound in quarter calf with wooden boards. Title printed in black on the front board. Enclosure formed with plasticine putty shaped to represent Yorick's skull, with hat made from calfskin suede. One of thirty numbered and signed copies. Unique version with accompanying skull, hat, and birch-root-veneer wooden stand also designed by Jan Sobota.

The book is smaller than most of those in Albert's collection, measuring less than one inch high.

PICTURED AT LEFT

JOY TONKIN

Shakespeare's Sonnets (Canberra, Australia: J. Tonkin, 2014)

Bound in decorative paper, with goatskin spine, gold tooling, and leather headbands. Paper for boards and endpapers made by Marianne Peters.

NOT PICTURED

BOOKCASES AND MODELS

UNKNOWN MAKER

Bookcase housing *The Plays of William Shakespeare*, 40 vols. (Glasgow: David Bryce and Son, 1904)

Mahogany veneer and glass, with brass knobs and hinges. Books bound in original gold-stamped limp leather. 11⅛ x 8½ x 4½ in.

Dedicated to the popular British actress Ellen Terry (1847–1928), this set was the smallest produced up to that time.[74] Each volume measures about 2 x 1½ inches, and all of them fit perfectly into this bookcase, making it likely that the bookcase was made for the set. However, the date and original owner are unknown.

PICTURED OPPOSITE

PAUL WELLS

Globe Theatre model

2010

Mixed media, including lime and pear woods, board, brass, and hemp, with acrylic paint and dry-powder pigments. 6 x 7 x 7 in.

PICTURED BELOW

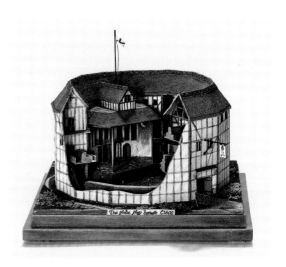

TIM GOSLING

Bookcase housing *Shakespeare's Works*, 40 vols. (London: Anthony Treherne, 1904–7)

2011

English walnut, with ebonized columns and gilded details. 17¾ x 14¼ x 10⅛ in. Books bound in leather by Valerie Levitt of Newcastle Bookshop Bindery.

The bookcase also includes five of the bronze and silver medals commissioned by the Shakespeare Birthplace Trust in 1964 to commemorate the four-hundredth anniversary of the playwright's birth. Designed by Paul Vincze (1907–94), the medals depict scenes from various Shakespeare plays. Galia Bazylko created the figure of Shakespeare seated at the front of the bookcase.

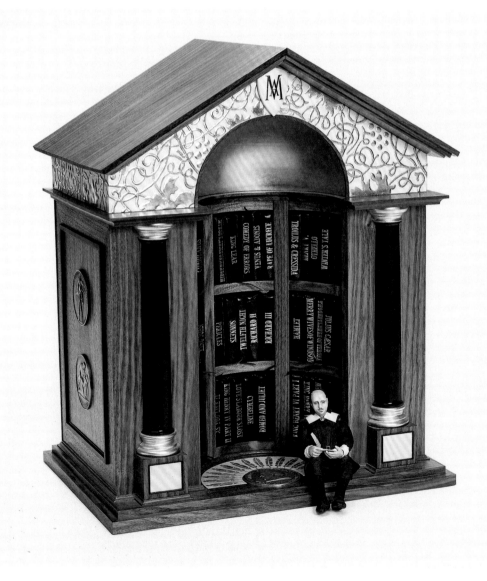

TIM GOSLING

Globe Theatre model

2015

Sycamore and harewood, with silver, gold, leather, platinum, and star sapphire. 9 x 9 x 7¾ in.

We used laser-etched sycamore for the main body and light harewood for detailing. The font was created for us by Vicki Ambery-Smith in silver and 18-carat gold, with a bezel stone setting to house the star sapphire. The leather inlay was created by George Kirkpatrick, the bookbinder and mutual friend of Neale and Tim Gosling's; it is die-embossed with platinum leaf in a design inspired by the zodiac. Every element has been handmade by various craftsmen in the UK.

The design that was laser-etched into the sycamore veneer was hand drawn by Tim. Because we normally design bespoke furniture, it's a fantastic pleasure to work on pieces of a much smaller scale. We have worked with Neale Albert previously on a beautiful miniature book-case [pictured opposite] to house his collection of minia-ture books of Shakespeare. And so with this latest piece, Neale was very trusting, allowing us to create a piece that was worthy of housing his beautiful star sapphire (given to him as a birthday present by his wife Margaret). Neale and Tim created the initial concept, with Neale suggesting the placement of the stone. Together, they maintained a dialogue throughout the design and making process.[75]

—Ruby Mogford, designer

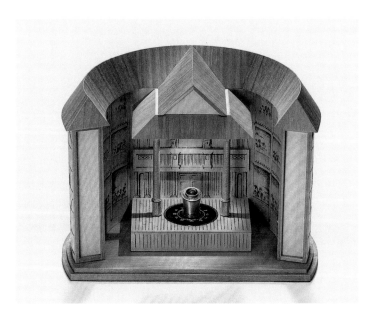

David Penton's studio in London, 2015.

Notes

1. Leonard Seastone, e-mail to Elisabeth Fairman, June 16, 2015.

2. Susan Allix, e-mail to Fairman, February 5, 2015.

3. Doublure: "An ornamental inside lining of a book cover, which takes the place of the regular pastedown and fly leaf . . . often very elaborately decorated." Matt Roberts and Don Etherington, *Bookbinding and the Conservation of Books: A Dictionary of Descriptive Terminology* (Washington, DC: Superintendent of Documents, 1994), http://cool.conservation-us.org/don/dt/dt1504.html. This dictionary is a good source of information for any unfamiliar bookbinding terms.

4. Palladium is aluminum leaf, used when a silver color is desired.

5. Edward Bayntun-Coward, e-mail via Annie Logan to Fairman, February 6, 2015.

6. James Brockman, letter to Neale Albert, September 10, 2010. Brockman conserved a copy of *The Book of Common Prayer*, bound in 1699 by Balley and housed at the private library at Wormsley in Buckinghamshire. John Bagford, writing in the eighteenth century, asserted that Balley "contrived to bind a book that at sight you could not know the fore-edge from the back." George Fletcher, ed., *The Wormsley Library: A Personal Selection by Sir Paul Getty, K.B.E.* (New York: Maggs Bros. in association with the Pierpont Morgan Library and Museum, 1999), 154.

7. Stuart Brockman, e-mail to Fairman, March 16, 2015.

8. Hannah Brown, e-mail to Fairman, February 23, 2015.

9. Lester Capon, e-mail to Fairman, March 19, 2015.

10. Mark Cockram, e-mail to Fairman, February 8, 2015.

11. Deborah Evetts, e-mail to Fairman, February 4, 2015.

12. Gabrielle Fox, e-mail to Fairman, March 22, 2015.

13. Annette Friedrich, e-mail to Fairman, February 21, 2015.

14. Sayaka Fukuda, e-mail to Fairman, February 13, 2015.

15. Eri Funazaki, e-mail to Fairman, February 25, 2015.

16. Jenni Grey, letter to Neale Albert, June 10, 2010.

17. Simeon Jones, e-mail to Fairman, May 18, 2015.

18. Derek Hood, e-mail to Fairman, February 19, 2015.

19. Angela James, e-mail to Fairman, February 9, 2015.

20. George Kirkpatrick, e-mail to Fairman, June 25, 2015.

21. Midori Kunikata-Cockram, e-mail to Fairman, March 21, 2015.

22. Monique Lallier, e-mail to Fairman, February 19, 2015.

23. Yuko Matsuno, letter to Neale Albert, July 16, 2011.

24. Yehuda Miklaf, letter to Neale Albert, October 24, 2010.

25. Tini Miura, e-mail to Fairman, March 18, 2015.

26. David Penton, letter to Neale Albert, February 28, 2010.

27. Eleanore Ramsey, e-mail to Fairman, May 27, 2015.

28. Sol Rébora, e-mail to Fairman, March 18, 2015.

29. Sean Richards, e-mail to Fairman, June 5, 2015.

30. Haein Song, e-mail to Fairman, February 21, 2015.

31. David Sellars, letter to Neale Albert, March 27, 2011.

32. Philip Smith, e-mail to Fairman, April 17, 2015.

33. Jarmila Jelena Sobota, e-mail to Fairman, March 19, 2015.

34. For more on fusion marquetry, see this binder's website: http://alain-taral-reliure.fr/en/.

35. Daniel Wray, e-mail to Fairman, February 24, 2015.

36. Quotations on this page and facing, Ann Tout, e-mail to Fairman, March 1, 2015.

37. Michael Wilcox, letter to Fairman, April 2, 2015.

38. Robert Wu, letter to Neale Albert, January 22, 2015.

39. Susan Allix, e-mail to Fairman, February 2, 2015.

40. Brugalla designed this miniature book to imitate a full-sized "Cosway-style" binding, with its characteristic painted miniatures on the front and back covers. Although this kind of binding is named after the leading miniaturist of the late eighteenth century, Richard Cosway, he had nothing to do with it. The style was introduced to the rare-book trade in the early twentieth century by John Stonehouse of the London-based Henry Sotheran and Company. Geoffrey Ashall Glaister, *Encyclopedia of the Book*, 2nd ed. (New Castle, DE and London: Oak Knoll Press and the British Library, 1996), 18.

41. Jo Bird, letter to Neale Albert, December 16, 2006.

42. Mark Cockram, e-mail to Fairman, March 16, 2015.

43. Three of the five bindings to which Delrue refers were commissioned by Albert.

44. The plough (or plow) is used by some binders for trimming the leaves of the book. See Roberts and Etherington, *Bookbinding and the Conservation of Books*, http://cool.conservation-us .org/don/dt/dt2131.html.

45. Paul Delrue, letter to Neale Albert, February 23, 2005.

46. Quotations on this page and previous, Sün Evrard, e-mail to Fairman, April 20, 2015.

47. Luciano Fagnola, e-mail to Fairman, March 31, 2015.

48. Jenni Grey, letter to Neale Albert, October 26, 2006.

49. Angela James, letter to Neale Albert, August 1, 2007.

50. Peter Jones, e-mail to Fairman, April 1, 2015.

51. *Henry the Fourth, The First Part* (Canterbury: George Kirkpatrick, 2006), 6.

52. Jeanette Koch, letter to Neale Albert, July 4, 2005.

53. Midori Kunikata-Cockram, e-mail to Fairman, March 21, 2015.

54. Quotations on this page and facing, Mia Leijonstedt, e-mail to Fairman, March 20, 2015.

55. Quotations on this page and facing, Eleanore Ramsey, e-mail to Fairman, March 9, 2015.

56. Jill Sellars described the binding on behalf of David Sellars, who had died in January of that year. She explained that "craquelle (or crackle) is a method of decorating calf leather by covering with a thick layer of paste and allowing it to dry out totally. The skin is then manipulated so that the dry layer of paste cracks, and colored dyes are then introduced. This can be done with a number of colors by re-pasting to achieve the desired effect. David learned the technique from the designer bookbinder Trevor Jones." E-mail to Fairman, June 25, 2015.

57. A Bradel binding, commonly used in Germany, is one that "allows the covers to be fit precisely to the text block, especially at the joint and fore-edge." For more information, see Peter Verheyen, "The German Case Binding," *Skin Deep* 22 (Autumn 2006): 2–7.

58. Jarmila Jelena Sobota, e-mail to Fairman, March 19, 2015. The Manesse Codex, or *Grosse Heidelberger Liederhandschrift*, is a medieval songbook copied and illustrated in Zürich (ca. 1300–ca. 1340), held in the University of Heidelberg collections.

59. Julian Thomas, e-mail to Fairman, May 21, 2015.

60. Hélène Francoeur, e-mail to Fairman, March 11, 2015.

61. Kate Holland, letter to Neale Albert, November 4, 2009.

62. Kate Holland, e-mail to Fairman, March 14, 2015.

63. Tom McEwan, e-mail to Fairman, March 22, 2015.

64. Quotations on this page and facing, Nicky Oliver, e-mail to Fairman, May 25, 2015.

65. Quotations on this page and facing, James Reid-Cunningham, e-mail to Fairman, March 7, 2015.

66. Johanna Röjgård, letter to Neale Albert, June 15, 2007.

67. Susan Allix, e-mail to Fairman, March 14, 2015.

68. Neale Albert amends Allix's story slightly: "My persuasions failed. Margaret bought the larger set for me as a birthday gift. She is more persuasive than I am." Email to Fairman, October 1, 2015.

69. Quotations on this page and facing, Susan Allix, e-mail to Fairman, March 14, 2015.

70. Stephen Byrne, e-mail to Fairman, April 22, 2015.

71. Quotations on this page and facing, Gabrielle Fox, e-mail to Fairman, March 22, 2015.

72. Kirkpatrick entered *The Tempest* in the Designer Bookbinders International Bookbinding Competition for 2013. (The theme was William Shakespeare.) He was listed as one of the "Distinguished Winners." http://www.designerbookbinders.org.uk/competitions/dbibc/2013 /international_competition2.html.

73. George Kirkpatrick, e-mail to Fairman, March 21, 2015.

74. Julian I. Edison, "William Shakespeare," *Miniature Book News* 3 (March 1966): 2. http://digital.library.unt.edu/ark:/67531/metadc9460/.

75. Ruby Mogford, e-mail to Fairman, March 26, 2015.

Acknowledgments

First and foremost, my thanks go to Neale Albert and his wife, Margaret, for without their support—and Neale's special love of all things diminutive, especially miniature books—neither the exhibition nor the publication would have come to be. It has been an enormous pleasure to work closely with Neale throughout this entire process, and I hope he enjoyed it as much as we all have. We are, of course, ecstatic that Neale and Margaret have promised to donate their collection of Shakespeare-related miniature designer bindings, small bookcases, scale models, and other Shakespeare-related works to the Center in due course.

Amy Meyers, Director of the Yale Center for British Art, has warmly and wholeheartedly supported the idea of the exhibition and the publication from the outset. Neither could have been completed without the assistance of Sarah Welcome, Senior Curatorial Assistant, my colleague in the Department of Rare Books and Manuscripts. Her contributions were invaluable, and I continue to be dazzled by her insights. I am grateful to A. Robin Hoffman, Assistant Curator of Exhibitions and Publications, who supervised the details of the book's production and worked with Nathan Flis, Acting Head of Exhibitions and Publications and Assistant Curator, on exhibition organization and implementation with aplomb. Her own love and appreciation of the book arts has made working with her on this project all the more rewarding. Shaunee Cole, Publications Assistant in the Department of Exhibitions and Publications, has gone beyond the call of duty, cheerfully tracking down elusive images and securing needed permissions. Christopher Lotis, Editor, also in the Department of Exhibitions and Publications, reviewed the text of the publication as well as the exhibition materials with characteristic thoroughness. We are grateful to both Phil Freshman, who edited the original manuscript, and to John Ewing, who brought fresh eyes at the proofreading stage.

I would like to thank Corey Myers, Associate Museum Registrar, who handled all the registrarial issues; and Rick Johnson, Chief of Installation,

OPPOSITE ABOVE: Trimmed text block prepared for edge decoration by Luciano Fagnola.

OPPOSITE BELOW: Fagnola polishing the decorated edge with a burnisher.

and his team, including Kevin Derken, Rachel Hellerich, Rick Omonte, Greg Shea, and Dylan Vitale, who installed the exhibition with their characteristic enthusiasm and cheerfulness. I would like to thank Beth Miller, Deputy Director for Advancement and External Affairs, and her team for their support, but particularly Betsy Kim, Head of Communications and Marketing, who did an outstanding job with all aspects of the public relations. Lyn Bell Rose, Head of Design, designed all signage, labels, and other printed material related to the exhibition with creative distinction.

I would like to extend special thanks to James Reid-Cunningham, who has written an inspired essay on designer bindings for the publication, from his perspective as both a book historian and a practitioner. He and Neale had a wonderful set of conversations about designer bindings, collecting, and patronage. James also provided crucial guidance, leading me out of the thicket of binding definitions when I became lost, and he uncomplainingly answered dozens of questions about the binding process. James's support has been vital for the success of this project, and I appreciate his patience in all things.

I am immensely grateful to all the designer binders who so thoughtfully responded to my queries. They provided descriptions of their bindings and shared their thoughts on the process of designing commissioned works for Neale Albert (and patrons like him), and on the binding of miniature books in general. We also received some wonderfully evocative photographs from and of the binders themselves, depicting their studios, their tools, and the process of binding these extraordinary works of art. We have made a selection of their contributions for this publication.

We would like to thank the talented Tom Grill, who took the marvelous photographs of Neale's miniature books, furniture pieces, and models. One can almost feel the texture of the covers in these images. His team at Tetra Images (Christopher Grill, Janet Prusa, and Valerie Saunders) could not have been more helpful during the photography session in his light-filled Jersey City studio.

The publication itself was beautifully and creatively designed by Miko McGinty, who, once again, has proven to be an incredible collaborator. This is our third collaboration, and as before, it has been an extraordinarily rewarding experience. She worked closely with Professional Graphics, who prepared the

color separations for printing with particular skillfulness. Her colleagues Rita Jules and Claire Bidwell assisted throughout the project, and Claire supervised the book's printing and binding by Conti Tipocolor in Florence, Italy. We would also like to acknowledge Claire's work as a hand model in photographs of the bindings where we wanted to remind our readers of the small scale of these lovely books.

Others whose assistance was invaluable include Edward Bayntun-Coward, Louise Brockman, Hannah Brown, Paola Fagnola, Michael Garbett, Peter Jones, Annie Logan, Ruby Mogford, Nelson Peltz, Jill Sellars, Jason Smith, Phil Sturdy, R. Scott Toop, Jayne Weighill-Smith, and Phil Weighill-Smith.

For the exhibition at the Yale Center for British Art, we are grateful to Gabrielle Fox, who has loaned a number of miniature tools that help illustrate the process of binding and decorating tiny books. We would like to thank Cynthia Sears and Frank Buxton for the loan of the head of King Lear, made by Philip Smith as an enclosure for the miniature book in Neale and Margaret Albert's collection. We are indebted to Philip Smith himself, who has loaned two of his extraordinary working notebooks, in which he has meticulously recorded the details of all the bindings he has made over his long career, including the Alberts' *King Lear* and *Brush Up Your Shakespeare*.

Elisabeth Fairman
January 2016

Derek Hood attaching headband of miniature book, 2015.

Index of Names

Photography Credits

Photographs of the bindings and their enclosures, the scale models, the furniture, and the Alberts' apartment are by Tom Grill, unless otherwise noted. Photographs of binders, their studios, or their tools are courtesy of the binders themselves, unless otherwise noted.

Tom Allen: pp. 26, 213
A. Belfield: p. 151
Federico Botta: pp. 149, 232
Alex Boyd: p. 189
Richard Caspole: p. 35, fig. 3
Lee Friedlander: p. 5
Stu Grimshaw/Pennleigh.com: p. 193
Ben Langdon: pp. 89, 235
Denis Larocque: pp. 182, 184
Library of Congress, Rare Book and Special Collections Division: p. 36, fig. 15
Courtesy Lilly Library, Indiana University, Bloomington, Indiana: p. 37, fig. 16
Eric Luse/San Francisco Chronicle/Polaris: p. 109
Miko McGinty: p. 24, fig. 11
Rick Meghiddo: p. 102
Daniel Pangbourne: p. 21
Steve Robinson: p. 210
Tracey Rowledge: p. 222
Courtesy of Philip Smith: p. 41, fig. 19; p. 175

Portraits of Neale Albert and the binder (detail), from *The Tempest*, bound by George Kirkpatrick, 2013 (pp. 180–81).

COLOPHON

Designed by Miko McGinty

Type composed in Adobe Caslon and Proba Pro
Color separations by Professional Graphics, Rockford, Illinois
Printed on GardaPat Kiara paper
Printed and bound by Conti Tipocolor, Florence, Italy

1/50 g7B 2007

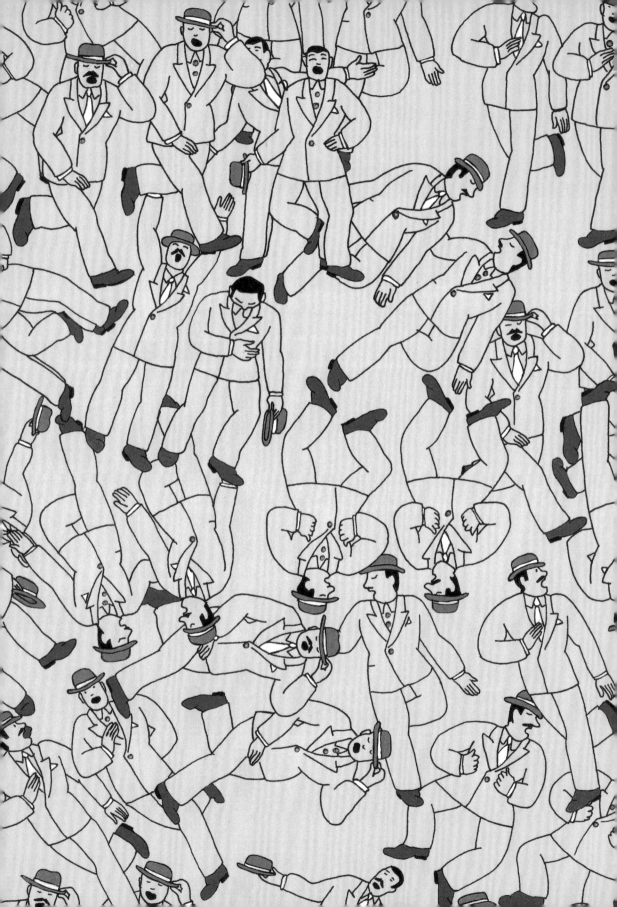